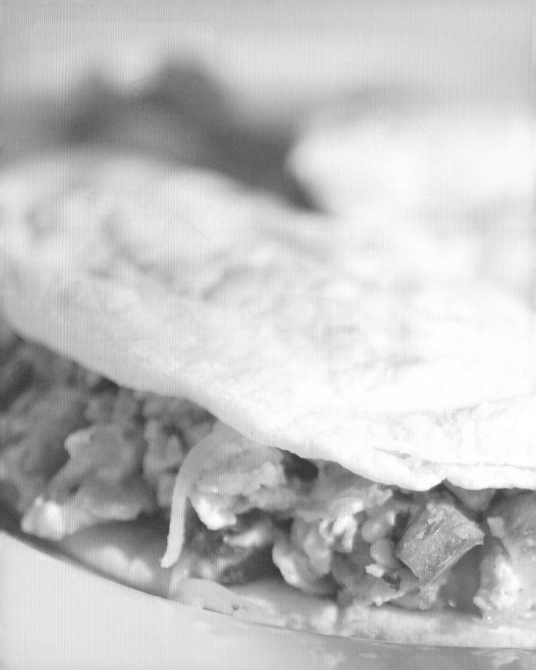

Austin ▷
BREAKFAST
TACOS

THE STORY OF THE MOST
IMPORTANT TACO
OF THE DAY

MANDO RAYO
· *and* ·
JAROD NEECE

PHOTOGRAPHY BY
JOEL SALCIDO &
DENNIS BURNETT

AMERICAN PALATE

Published by American Palate
A Division of The History Press
Charleston, SC 29403
www.historypress.net

Page 1: Illustration by Pepe Yz, PepeYz.com.
Title page: Migas breakfast taco from Joe's Bakery. *Photo by Joel Salcido.*
Opposite, top: Mando Rayo y familia. Quetzal, Argentina Granada, Ixchel Granada de Rayo
and Diego and Mando Rayo. *Photo by Joel Salcido.*
Opposite, bottom: Jarod Neece y familia. Francesca, Andrea Yz, Jarod and Tessa Neece. *Photo by
Dennis Burnett.*

First published 2013

Manufactured in the United States

ISBN 978.1.62619.049.8

Library of Congress CIP data applied for.

Dedicated to Austin, Texas, and our families.

I would like to dedicate the tacos and this book to mi familia *for their support,* amor y cariño. Los quiero un monton!
Ixchel Granada de Rayo
Quetzal Trinidad Rayo
Diego Armando Tenoch Rayo
–Mando Rayo

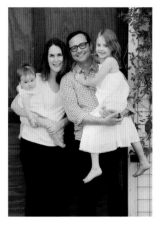

I dedicate this book to my amazing wife, Andrea, and our two beautiful daughters, Tessa and Francesca. Y'all make all the taco meals taste better when we eat them together!
–Jarod Neece

CONTENTS

TACOS. NEVER. DIE.

Taco Journalism

MIL GRACIAS!

Thanks to everyone who helped us with the book!

Aaron Franklin
Adam Holzband and Jodi Bart
 Holzband
Addie Broyles
Alex Rayo
Alfredo Santos
Alton Jenkins
Amy Averett
Andrea Yz
Argentina Granada
Aurelio Torres
Bianka Becerra
Brittany Platt
Carmen Valera
Catherine Robb
Cathy Lippincott
Celeste and Adrian Quesada
Christen Thompson
Claudette Godfrey
Clovis Cisneros
Cody Symington

Cristina Balli
Daniel Macias
David Alan and Joe Eifler
David Ansel
Dennis Burnett
Diana Cisneros
Diane Valera
Dorsey Barger and Susan
 Hausmann
Elaine and Rich Garza
Elizabeth Englehart
Eric and Diana Orta
Eric Wilkerson
Fidel Martinez
George Milton
Glenn Rosales
Gloria Espitia
Gordon Murphy
Hoover Alexander
Ixchel Granada de Rayo
Jake Agger

Javier and Stacey Rayo
Jessika Gomez-Duarte
Jesus Becerra
Dr. Jesus Frank de la Teja
Joel Salcido
John Conley
Jorge Garcia
Jose de Loera
Jose Luis Perez
Jose Velasquez
Juan Castillo Jr.
Juan Castillo Sr.
Juan P. Meza
Justin Bankston
Kathy Vale
Laura Williamson
Lauren Eichhorn
Lisa Albracht
Llyas Salahud-Din
Lonnie Limon and Crystal Cantu
Lorena Vargas
Manuel Lopez Galvan
Marcel Rodriguez
Margarita Mendez
Maria Corbalan
Maria Vargas
Maritza Vasquez
Mary Jenkins

Michael Barnes
Mike Martinez
Mike Rypka
Mindy Stoddard
Myrna Y. Meza
Nestor Mendez
Nikki Ibarra
Nilda de la Llata
Omar L. Gallaga
Pauline Avila
Paul Qui and Deana Saukam
Pepe Yz
Paulina Artieda
Rafael Picco
Raquel Vargas
Ray Gonzalez
Regina Estrada
Reyna Vasquez
Roberto Espinosa
Roberto Vasquez
Robert Valera
Rose Ann Maciel
Sam Armstrong
Sarah Hickman
Sergio Valera
Tim and Karrie League
Virgil Ojeda Limon and Diana
 Estrada Limon

AND NOW A BREAKFAST TACO SERVICE ANNOUNCEMENT

We're no writers; we're no historians; we're no chefs. We're just a couple of guys who love breakfast tacos. Join us as we discover the breakfast taco, the *taqueros* (aka taco makers) and the people of Austin who love them so much. Tacos are messy, and so is this book, so don't expect fancy recipes or elaborate ways to cook up your breakfast tacos. Our photog style and our writing are just like breakfast tacos: down-and-dirty and messy! Tacos are the people's food, yo! We'll have lots of recipes—some full, some *al gusto*. We hope this book will make you hungry and want to go eat breakfast tacos, like immediately!

PART I

AUSTIN, TEXAS

THE BREAKFAST TACO CAPITAL OF THE WORLD

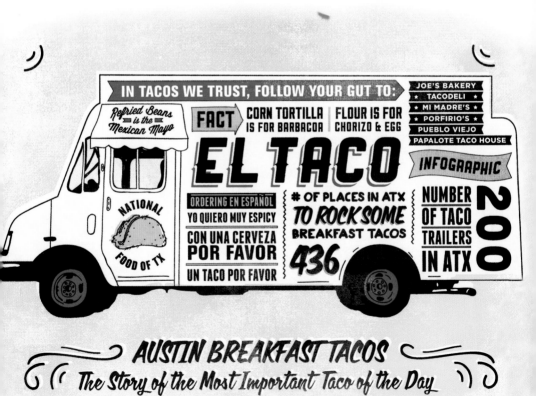

IN TACOS WE TRUST, FOLLOW YOUR GUT TO:

JOE'S BAKERY
★ TACODELI ★
★ MI MADRE'S ★
★ PORFIRIO'S ★
PUEBLO VIEJO
PAPALOTE TACO HOUSE

Refried Beans is the *Mexican Mayo*

FACT CORN TORTILLA IS FOR BARBACOA | FLOUR IS FOR CHORIZO & EGG

EL TACO

INFOGRAPHIC

NATIONAL FOOD OF TX

ORDERING EN ESPAÑOL
YO QUIERO MUY ESPICY
CON UNA CERVEZA POR FAVOR
UN TACO POR FAVOR

OF PLACES IN ATX TO ROCK SOME BREAKFAST TACOS 436

NUMBER OF TACO TRAILERS IN ATX 200

AUSTIN BREAKFAST TACOS
The Story of the Most Important Taco of the Day

AUSTIN'S LOVE OF THE BREAKFAST TACO

Austin: the Breakfast Taco Capital of the World? Hell yeah it is! And why not? The people of Austin love their breakfast tacos; they love them in the morning, for lunch, when they're hungover, at midnight, on the streets and in *abuelita's cocina*! Wherever you go in Austin, you'll find taqueros creating a plethora of the breakfast creations that are part of the culture of Austin. We've got so many people making breakfast tacos that people were going crazy when they heard of the bacon shortage of 2012. Not only do we have traditional taqueros making them, but we also have pit masters, restaurateurs and all kinds of taco-making cooks hookin' up breakfast tacos for the people of Austin. Last time I checked, we had over 370 places in Austin that serve breakfast tacos. Shoot, as I'm writing and enjoying a *cafecito* at Bennu Coffee, I might just get one right now. Yeah, that's also a big thing in Austin. Coffee shop tacos.

Why do we love the breakfast taco? I think it's a mix of things. We love the simplicity of the breakfast taco, the options, the comfort it gives us in our bellies and, of course, *los huevos*. Gotta have eggs for breakfast, right? But not necessarily in the morning. You can have breakfast tacos at almost any time of the day, and for a lot of Austinites, after a long night working, at a show or just going out, they really hit the spot, whether you wake up at 8:00 a.m., 2:00 p.m. or even 6:00 p.m.

When in Austin, do as Austinites do. Eat barbecue, listen to live music, hang out in the East Austin bar scene (yeah, just ask *los hipsters*) and eat lots of breakfast tacos. *La cultura de* Austin is to do just that, and there are many reasons why Austinites are avid taco fans. Yes, we're a university town; we do have our share of college tacos, and students eat them up because they're cheap, quick and easy to handle. The affordability factor is a big one. You can still get breakfast tacos for one to two dollars in the east side, and that meal can get you through lunchtime. We're also an open people—or, as we say, we like to "Keep Austin Weird." (Yes, I'm going there because it's true!) I like to think that Austin has an openness to it. We're somewhat of a metropolitan city (at least we're getting there), and most cities like Austin are more open to new experiences, new cultures and new people. We aren't afraid of trying new things. That's pretty good for Texas, right? Our willingness to try new things is one of the reasons we love the breakfast taco. Being close to the border helps, too. Whether it's taco trailers or brick-and-mortar restaurants, we've experienced the influence of Mexican and Latino immigrants, Tejanos, Mexican-Americans and Chicanos in the city. And what do we do? We accept their (and my) taco ways with open arms! And for that, I thank you, Austin.

Es un fusion of the old and the new, rooted in Mexican tradition but evolving in Austin and beyond and forming a new food experience and culture that are unique to our little town. And why not? We can have the traditional Mexican from Veracruz All Natural to Tex-Mex at Joe's Bakery and try new ways of eating and making tacos with Tacodeli and Torchy's. All this mixing is part of the Austin way of life. We love our food, and that's a

space where we don't really have any boundaries—*nomas hazle* Google *a todos los trailers* in Austin!

Austin: *puros foodies aquí*. Seriously, with over two hundred food bloggers in town and the chef-run food trailers popping up almost every weekend, Austin has become quite the food scene. From Paul Qui's Eastside King to Tacodeli's organic breakfast taco options, we're experiencing the evolution of food service out of trailers and coffee shops. But let's not forget where this all got started. We have to thank Mexicans and Mexican-Americans from as far back as 1919, when they set up chili stands in downtown Austin, and the taco trailer influx of the 1990s. Yeah, remember that? Those were the days!

Part Mexican, part American and 100 percent Tejano, breakfast tacos are a unique food that can only be found in Texas, and we love to tell the world about them. Just like with pizza in New York, hot dogs in Chicago, *cabrito* in the Rio Grande Valley, puffy tacos in San Antonio, Chico's Tacos in El Paso and Dallas's Gas Station Tacos, it is the people's love of the food that makes them and their cities popular. Now, the breakfast taco may not have originated in Austin, but it's the love affair that Austinites have with the handheld food that makes it so popular. People of Austin love it so much that they're broadcasting it to the world, and now anyone visiting Austin—from New Yorkers to TV show celebs to Californios—have to have breakfast tacos. It's the many breakfast taco options and plethora of people who love them that really make Austin the Breakfast Taco Capital of the World.

HISTORY OF THE BREAKFAST TACO IN AUSTIN

It all started with Old Mexican town—what is now Republic Square Park at Guadalupe and Fifth Streets. That's where the first Mexicans lived—right in downtown Austin. Before condos and the east side, families who emigrated from Mexico settled in Austin in the 1870s. A handful of immigrants came here for a better life and worked as soda jerks, ranch hands and workers in tortilla and chili factories. Those were the early days of Mexican life in Austin.

In the 1890s and early 1900s, the development of Mexican-owned businesses—a meat market (Ben Garza), a doctor's office (Alberto Garcia), the first tortilla factory (Crescenciano Segovia; Austin Tortilla Manufacturing Company, 1922) in Austin and the predecessor to the taco trailers—sprouted up in the form of tamale and chili stands. In an *Austin American-Statesman* article from the 1950s, writer Hamilton Wright professed, "Back in 1893 on the courthouse square one had no trouble finding a Mexican vendor." And so began the influence of Mexican culture into what we now know of taco trailers, Mexican and Tex-Mex food and cuisine.

During the Depression and into the 1930s and '40s, Austin experienced the emergence of Mexican restaurants by the Carlin family (Jose Trujillo Carlin and Elvira Hernandez), including El Charro Restaurant (Red River and Ninth Street) and El Charro #2 (on Speedway by the University of Texas) and La Tapatia. During a time when the Mexican community was

establishing itself, the 1928 City Plan for Austin relocated Mexicans to the east side of town to segregate minority communities. Mexicans and Latinos have a culture of being entrepreneurial, and soon more restaurants were established, including El Mat, "home of the crispy taco" (1947); El Matamoros Restaurant (1957); and Matt's El Rancho (1952). Local east side favorites like Joe's Bakery (1962), El Azteca (1963) and Cisco's Restaurant Bakery (1959) settled in East Austin and are still open today.

The basic formula of these restaurants was to serve their customers food just like they would make at home, but there was still no sign of breakfast tacos like we have today.

From the 1970s to the 1990s, the United States experienced exponential growth in immigration. Austin was no exception. With increased community members from Mexico and Central and South America, and mixed with multigenerational Tejanos, Austin's food scene started to boom. It was in the early 1980s when the commercialization of breakfast tacos began with the Tamale House on Airport Road, Las Manitas on Congress and other established restaurants. In the late 1980s and early 1990s, Austin experienced a growth of small Latino-owned businesses

in the form of taco trucks and trailers. Soon thereafter, chefs and other entrepreneurs followed suit, and today Austin is a mecca for food trailers.

In sharing the history of the breakfast taco, I interviewed people I call *Los Elders*, restaurateurs and Austinites who have longer histories than what's in libraries and articles. These are some of their stories.

A LITTLE HISTORY

Let me go back a bit. Our grandfather came from Mexico. He established Tony's Tortilla Factory right on Seventh and Lydia. My mother managed the business for many, many years.

I guess I was born with a taco in my mouth because we had them from day one. There were always hot tortillas on the table. We would love to put butter and salt and eat tacos just as they were being made. So we had tacos very early on, and we would eat mainly beans, rice and fideo. We didn't have a lot of meat, and the only meat we would eat was hamburger meat once in a while.

I guess I was about thirteen years old when my parents opened the Tamale House on First and Congress, and it was the new concept of Mexican food to go. My mother and father made the tamales by hand and sold them for about fifty cents a dozen. This was in 1959. After they opened that one, they opened one on South Lamar. I was about fifteen, and I managed that second location for awhile. My brother Robert opened his place up in 1977. I have a sister that opened one on Guadalupe. It's not operating now. I was the first one who went into the sit-down/full-service restaurant business. It's a lot of work, and that was in 1984. I called it Mexico Tipico. I operated that until 2000, when I went into real estate. Now I have been drawn back into this by my children, who decided that they wanted to try their hand at it. As a result, my five children are running Tamale House East. It's based on the concept of the original Tamale House, my brother's Tamale House and Mexico Tipico all wrapped into one. So it varies a little bit. It has

a little Latin American influence sometimes. But it's all the original good food taught to us by my mother.

I was born in 1948. Robert is eight years older than me, so I think that the time when that happened, Mexican food wasn't really popular food like it is now. Also, this area was separated not only by the physical barrier of I-35 but also a mental barrier. The Hispanic community was more or less on the east side, and there were a lot of family-owned businesses, tortilla factories and panaderias. And as is customary in Hispanic culture, we are usually above our business or behind our business. We lived, breathed and ate our business. In that similar mode, we live above this business. We always have.

ON THE BREAKFAST TACO

It's like a mini home-cooked meal in a tortilla. It takes a lot of effort and love to put the ingredients that go into it. It's not like flipping burgers. The more ingredients it has, the more care and love it has. But I think in addition to that is the evolution of the appreciation of our culture. And part of a culture is their food, their music, their language. There have been a lot of people who have traveled to Austin and discovered what wonderful tacos we have and have written about it and done stories about it. For the longest time, our own community didn't know what a gem they had, which was our whole culture and our food. Mexican food is so varied. Every taco is a little piece of art. I get into the kitchen, and a customer might ask me how much are you going to put of that ingredient? And I say, well, put on some music and lemme see. That's how I personally do it. I'll remember recipes from my mother or that I've seen elsewhere. It's a creative endeavor. When someone comes in, they can tell that. They can look at a taco, the greens, the reds. It's colorful like a Mexican flag or a Mexican costume. When people visually see the presentation of the taco, they get excited, and

when they put it in their mouth, they say, "Wow, I've discovered something." And every time someone tries it, I can tell people enjoy it. It's a very rewarding experience to make someone happy. It's a very basic instinct in all of us that if you satisfy someone's hunger or a craving for delicious food, you make them happy. And they want to come back. And they want to share that with their friends.

I just want to add that I think it is wonderful that we are finally being recognized as a culture and that we are able to share this wonderful food, and these wonderful tacos, with so many people from Austin and from outside Austin and outside the country.

Robert Vasquez, Tamale House (Airport Boulevard)

BREAKFAST TACOS TAKE OFF

I don't think anyone was selling breakfast tacos when I opened up. I think I was in business for five or six years before I actually started selling breakfast tacos. It means you gotta get up at four o'clock in the morning to make a breakfast taco. When I started in 1985–86, I started selling them. A neighbor down the street was selling them, too. So I started a taco war. My tacos went down to forty-five cents each. So he went out of business, and I kept going. About that time, my mother and my sister started selling breakfast tacos, too. Now, if you look around, everybody's selling breakfast tacos. Everybody. McDonald's, Wendy's, Taco Bell. They never used to do it before. It's something that's caught on...I make all my stuff in-house. We don't have anything imported. It's all made right here in our kitchens. The only thing we buy are the tortillas, but they're local.

EATING TACOS, THEN AND NOW

You wanna know what it was like as a kid eating tacos? If I took tacos to school, everyone would say shame on you. There was a lot of shame eating a taco back then. You had to hide them. You couldn't eat them in front of nobody. And this was among a school that was 80 to 90 percent Anglo and very few Mexicans. So I had to hide my food. But now, 80 to 90 percent of Anglos eat tacos! I would say 80 to 90 percent of my customers are Anglo. And they eat tacos like they've never had anything before in their life! So things have changed. I think to myself, I remember a time when I would get made fun of. And now everybody's eating tacos. It's not just Mexicans anymore.

FIRST SUCCESSFUL MEXICAN FAMILY IN AUSTIN

My name is Glenn Martin Rosales. I was born in San Benito in the Lower Rio Grande Valley in 1954, and I lived there until 1972, when I moved here to Austin. This is my mother's hometown. And her mother's, Elvira Hernandez, hometown. Born here in what was then known as Mexican Town in West Austin. My grandmother grew up working in other people's homes. In the homes of the more affluent that had workers come and clean and iron.

My grandfather came when he was sixteen years old. He was born in San Diego de Alejandria, Jalisco, Mexico. His first job was as a soda jerk. He met my grandmother, Elvira Hernandez. They got together, and they started a restaurant in the 1930s called El Charro on Red River and Ninth. Today, it's called Mohawk. They started another El Charro #2 over by speedway, near UT.

They started another restaurant called La Tapatia. A very famous restaurant. I remember coming to visit in the '60s, and people were lined up down the street because it was a very good restaurant. My grandmother and my grandfather also owned cafés, other bars—about seven other businesses. They were well-to-do at that time for Hispanos, Mexicanos. And they would entertain at their home; they would serve the same food they served at the restaurants at their parties.

At that time, the men were the ones in charge. They were the businesspeople. My mom was busy raising children, as well as working at the restaurant. In 1949, my grandfather died at the age of thirty-eight. My grandmother had five small

children, and she had all these businesses. She couldn't run the family and the businesses, so she started selling the businesses. So soon after, she started selling the restaurants.

PAULINE AVILA, JOE'S BAKERY AND RESTAURANT

THE BAKERY

I was born on a farm right off of Manchaca Road here in Austin. I've been here all my life. We moved from the country off Manchaca to the city in 1945. I was born in 1938; I'm seventy-five years old. My dad died in 1946, so we were brought up by my mom. I started to work when I was ten years old picking cotton, and my mom would take all ten brothers and sisters out to the fields to work. I met Joe and married him when I was seventeen. Joe's dad was ill, and his mom turned the bakery over to him. So we got started around 1962. And that's when we started the bakery on Seventh Street. We had our first bakery right where the Short Stop is now.

EATING TACOS

Tacos were the standard food for Mexican people. I remember making the tacos and taking them to lunch, and we would take them to my dad and my brothers working in the field. And we would take tacos to school since they didn't have any money to give us for lunch. But we had to hide them so the other kids wouldn't laugh at us. It was only a nickel for the lunch, but my mom didn't even have that. A lot of the kids who didn't have enough money to buy lunch would also have tacos, and we

would eat them behind the burning alley where they would burn the trash. Now everybody eats tacos. Back then, there was a lot of discrimination against Mexican people. When Joe went to a restaurant, they would have a sign that this section is for white and the other section was black and Mexican people. I'd say maybe even in the '60s you would start to see white people/black people eating tortillas. The breakfast tacos, bean and egg, chorizo—all those were popular even in the '60s.

BREAKING TORTILLAS

COWBOYS AND VAQUEROS

Down in the West Texas town of...Austin? No. But this is still cowboy country, right? Let me tell you about this *leyenda*. True or not, you be the judge—and historians, don't judge me. Part of my discovery exercise with this book is to find out how the breakfast taco came to be. Well, here it is.

Back in the day, circa 1800s, in the days of cowboys and *vaqueros* in this big ol' state called *Tejas*, vaqueros worked to drive cattle from Texas to Mexico while the Texan cowboys made land deals and worked on the ranches (although cowboys also worked on cattle drives, obviously). Remember, this is my myth. As you know, the cowboys' breakfast typically consists of eggs, bacon, sausage and biscuits. Over history, Mexicans have been known to eat a taco or two for lunch or dinner, but for breakfast? I don't know. The vaqueros of the past—and to this day, Mexicans and many Latinos I know—used the tortilla as a utensil. Shoot, I do it with my *huevos estrellados* all the time. Tear off a piece and scoop up the eggs—you should try it. While *muchos* Mexicans eat eggs for breakfast, they may not necessarily make breakfast tacos. I know I didn't grow up with them.

But I digress. So one day, the cowboys and vaqueros were eating their *desayunos*, separately of course, when Garrett the cook noticed that they were out of biscuits. What's a cowboy to do? Well, luckily for them, they worked side-by-side with some friendly vaqueros who were *muy* generous

and willing to share their fresh, buttery tortillas. What happened next changed the world according to Texas, and the breakfast taco was born when Garrett and Juanito shared a folded tortilla with bacon and eggs. *Yee haw!* and *Ajua!*—the breakfast taco was born. What do you think? Prove me wrong, historians.

BREAKFAST TACO 101

You've heard of a taco before, like from Taco Bell or your *abuelita*, but maybe you're not too familiar with a breakfast taco. Let me tell you about the goodness of the breakfast taco. It's food for the soul folded in half and stuffed with eggs and your favorite fillings. Yeah, that's pretty much it. Want to learn more? Keep reading!

THE TORTILLA,
ALSO KNOWN AS LA TORTILLA

Well, you can't have a friggin' breakfast taco without a tortilla. Stop listening to anyone who tells you that you can have a taco in a bowl without a tortilla. That's just ridiculous!

A tortilla is the foundation of the breakfast taco. They come in all shapes and sizes, but the best ones are round, and they're best eaten fresh, with butter and directly from your abuelita's kitchen. If you don't have one—an

abuelita, that is—you can pick up some tacos at your local H-E-B or any self-respecting Austin restaurant that sells breakfast tacos.

Corn or flour? That depends on what you're having and also what you like. Some traditionalists like me only do *barbacoa* on corn, and others like flour tortillas with all of their tacos. That's the beauty of the breakfast taco—you can mix and match and eat one or three or four at time, depending on the size of your belly.

TOOLS OF THE TACO

If you have the extra time, make your tortillas yourself and heat them up properly. Here are some tools you'll need to do it right.

comal: a round cast-iron griddle often used in Mexican cooking. If you don't have one, just go to your nearest flea market.

electric stove and microwaves: don't do it. If you do, you're probably just eating college tacos.

gas stove: you can heat up your tortillas on a gas stove burner. You'll need Mexican hands, though.

Mexican hands: the agility that comes from being a Mexican cook who can singlehandedly flip a tortilla while on the flame without burning your hands or fingers. Start practicing—or use tongs.

tortilla press: two metal discs with handles that flatten your masa balls into tortilla goodness.

un sartén/pan: warm up your torts in a regular old pan—does the trick!

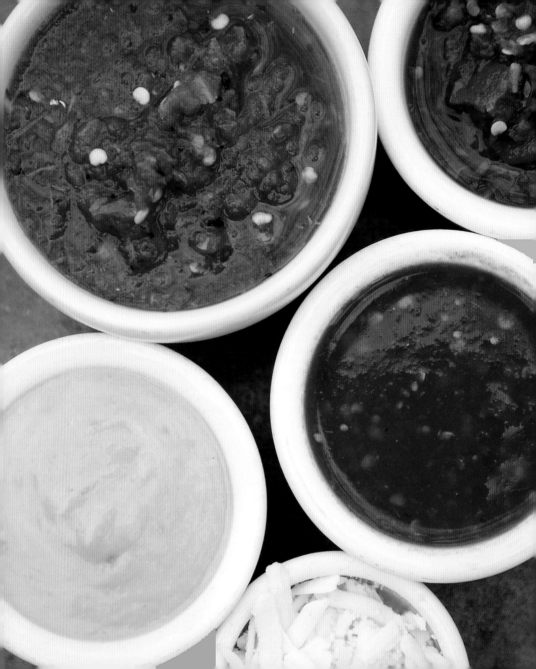

SALSA

There are many types of salsas in Austin, and each restaurant and family has its own style and flavor. From red to green to everything in between, cold to warm, fruity to savory, roasted to raw, spicy to mild, salsas are literally the icing on the taco, and they can make or break a good taco.

fruit-based salsa: mix it up! Peaches and mangos in salsas work great.

green salsa: jalapeños or tomatillos or avocados with spices and peppers.

pico de gallo: minced tomatoes, onion, cilantro and jalapeño—adds a great texture to sometimes one-dimensional and soft breakfast tacos.

red salsa: pureed or chopped tomatoes, usually with peppers, spice and onions.

We love most salsas, and it's usually the first thing we try at a restaurant when we sit down. It's the canary in the coal mine, and if the salsa is weak or bland, it's a sign of bad things to come. If the salsa knocks you out or is different than anything you've ever tried, you can bet the food will follow suit.

Some of our favorite store-bought salsas are Jardine's 7J Ranch Campfire Roasted Salsa, Tears of Joy's Tequila Lime and any of the Austin Hot Sauce Fest Winner's Salsas! Speaking of hot sauces, Cholula is my dark master and Aztexan Habanero Hot Sauce is also pretty special. Also, when in

Austin, eat that green sauce—it's jalapeño-based, creamy green salsa often found at taquerias, trailers, *pollo regios* and *los maestros* of the Doña Sauce at Tacodeli.

Need more? If you can brave the heat in August, head over (and bring your own bag of chips) to the Austin Hot Sauce Festival. It's a great way to try new salsas and see what home chefs and restaurants are making each year.

BREAKFAST TACO INGREDIENTS

avocado: wanna add some good monounsaturated fat to your breakfast taco? Throw some avo up there!

bacon: crispy, chopped or whole, battered or fried. This is an essential breakfast taco staple.

barbacoa: stewed cow cheeks—great flavor when you can get it and goes great with eggs. Don't forget the *cebollitas y cilantro*!

beans: refried beans are the Mexican mayonnaise. Black beans and Boracho style work as well. Add some to your next taco.

carne guisada: break the fast with some stewed meats.

cheese: yellow or white, Cotija or Queso Fresco, this tops things off nicely.

chorizo: greasy, crumbly sausage goodness.

fajita: need grilled beef at every meal? Don't be afraid to add some steak fajita to your breakfast taco.

huevos: mostly scrambled, sometimes fried, always delicious.

machacado: dried and reconstituted shredded beef. Just like abuelita used to make!

nopalitos: these sautéed cactus pads are a nice breakfast taco filling option. Great for vegetarians.

potatoes: Carbs on carbs on carbs! Another breakfast taco stalwart.

sausage: a reasonable bacon alternative that adds a nice texture to breakfast tacos.

sautéed vegetables: onions, poblano peppers, mushrooms, green beans—you name it.

tortilla chips: these turn boring scrambled eggs into *migas*! They also give your taco some nice texture and crunch.

weenies (aka franks): traditional Mexico City breakfast filling.

Part III

Austinites Love Breakfast Tacos

The people of Austin have spoken: they love their breakfast tacos! Austin has a fascination and love affair with the breakfast taco. Whether they're from trailers to more fancy ones, simple to complicated, meaty to veggie, they're the perfect food. The reasons are endless, but if I had to describe it, I'd go with Diane Varela from the Tamale House East's reasoning: "It's like a mini home-cooked meal in a tortilla."

We asked the people of Austin to contribute to *el libro de los breakfast tacos* and were *todo* excited by the people who came to our taco table. *Aqui estan*, the Austinites—their love for breakfast tacos and recipes.

PEOPLE AND RECIPES

Tell us about yourself and your connection with Austin...and the breakfast taco.

Even though I was raised in southwest Missouri, my family ate a lot of breakfast tacos growing up. We (foolishly) called them breakfast burritos, but that quickly changed when I moved to Austin in 2005. I've always been a savory breakfast kind of person, but it was only a matter of time before I couldn't think of something savory to eat for breakfast that was not a breakfast taco. I didn't start making migas until I started to grow a little tired of the traditional bacon, eggs and cheese breakfast tacos and when I decided that vegetables for breakfast was a pretty good way to sneak even more greens into my diet. I make a living writing about food for the Austin American-Statesman, *but I don't consider myself a professional cook, and this recipe for migas is one that anyone with a frying pan, eggs and stale tortilla chips can make. (And yes, fresh chips will work in a pinch, but I save the last crumbles in the tortilla chip bag specifically for making migas.)*

Whatever else you decide to put in your taco will evolve by the day and by your tastes. I used chopped Brussels sprouts for this version because that's what I had in my vegetable crisper, but I've made it with leftover roasted sweet potatoes, last night's

grilled zucchini or quickly sautéed chard or kale. Cheese isn't absolutely necessary, but I do like to throw a little in there to finish the dish.

What is your favorite Austin breakfast taco and why?
I've always been partial to the giant, super cheesy breakfast tacos at Los Jaliscienses, which also serves really good aguas frescas. I have the number of the one by my house listed in my phone as "breakfast tacos."

My Morning Migas

2 tablespoons salted butter, divided
½ cup chopped Brussels sprouts, stems removed
½ cup lightly crushed stale tortilla chips
3 eggs, gently beaten
2 tablespoons shredded cheese (optional)
Salt, pepper and Sriracha to taste
2 flour tortillas

In a small sauté pan over medium heat, melt 1 tablespoon butter. Gently sauté the sprouts until they start to soften and turn bright green. Add the last of the butter and the chips. Stir to coat the chips in butter and continue cooking and stirring until the chips are lightly toasted and the sprouts have cooked for another few minutes. Add the eggs and cheese to the pan. Cook as you would scrambled eggs, stirring regularly but not constantly to ensure that the eggs cook evenly. If cooking on a gas stove, warm tortillas over flame (or in a pan or griddle, if need be).

Remove from heat and fill the tortillas with the migas. Top with Sriracha or other hot sauce, as desired, and enjoy.

Serves 1 generously or 2 for a smaller breakfast.

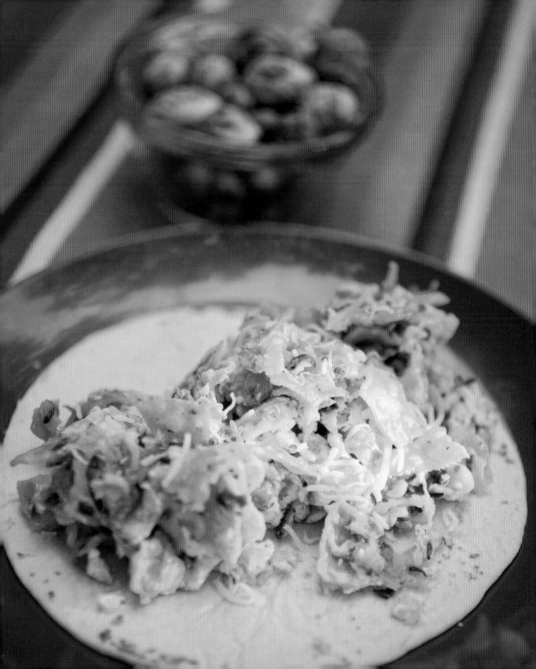

Tell us about yourself and your connection with Austin...and the breakfast taco.
I've been eating breakfast tacos since 1995, when I moved to Austin. You can't get any better or faster breakfast than a taco.

What is your favorite Austin breakfast taco and why?
Hmm. I would probably say...nowhere specific, but chorizo, potato and cheese. The greasier, the better.

BREAKFAST TACO RECIPE

Buttery hot tortilla, preferably from El Milagro
Brisket, sliced or chopped, preferably from Franklin Barbecue
Fresh salsa
Slices of avocado

CATHERINE ROBB, GRANDDAUGHTER OF LYNDON JOHNSON AND LADY BIRD JOHNSON

Tell us about yourself and your connection with Austin...and the breakfast taco.
I have been living in Austin full time since 1995, when I moved here for law school, but I grew up coming here—and to the Hill Country—to visit my grandmother every Christmas and every summer. I was also baptized here. Although I've always loved so many things about Austin and Central Texas, I don't think I began to fully appreciate the breakfast taco until I moved here for law school—when I first realized that, like ice cream (another favorite of mine), a breakfast taco, just by virtue of being a breakfast taco, is inherently delicious. I have since made up for not having them for the first twenty or so years of my life.

What is your favorite Austin breakfast taco and why?
I think that my two favorite places to get breakfast tacos are Tamale House and Tacodeli. I started going to Tamale House during my first year of law school. A good friend and I would play racquetball before our first class, and the loser had to buy the post-game breakfast tacos. My friends and I went there any time we could in law school. The breakfast tacos were delicious and very inexpensive. The salsa was terrific. I still go there some, but less frequently—although writing this makes me want to go get some right now! Egg, potato and cheese is my favorite there and most places.

My other favorite place (and breakfast taco) is Tacodeli. I (again) love the egg, potato and cheese, and they make them with mashed potatoes rather than chunks of potato. Their egg, chorizo and cheese tacos are really good, as well. And, although the tacos are really good without any sauce/salsa, they have great salsas.

How do you like your breakfast tacos?

I am sort of a purist (see above), so I love the basic egg, potato and cheese. But my other favorite, which reminds me of many very happy mornings out at our ranch in Stonewall, is egg and bacon with great salsa. I did not really make those, unless I can claim credit for taking a warm tortilla out of the tortilla warmer and taking the bacon and eggs on my plate and putting them inside the tortilla, along with some delicious salsa. If so, sign me up as a fantastic maker of breakfast tacos! The ranch is one of the only places I always ate bacon, and we would have the best homemade tortillas and homemade salsa (along with great scrambled eggs). So, when I make breakfast tacos, it is usually pretty basic—egg, potato and cheese or egg and bacon. They don't have the wonderful homemade tortillas and salsa I remember from the ranch, although I am now feeling inspired to try my own in the near future.

Tell us about yourself and your connection with Austin...and the breakfast taco.

Our household's family tree stems from Austin and Laredo, Texas. We managed to magically combine the vegetarian, relatively hippie Austin mentality with the meat-loving carne asada traditions of Laredo under one culinary roof that is Casita Quesada.

Celeste, born and raised in Austin, Texas, has fond memories of going to her grandmother's house and watching her mama make fluffy white flour tortillas. Who cared what was in the taco when the tortilla was homemade by the loving hands of her grandmother?

Adrian, born and raised in Laredo, Texas, never knew what a breakfast taco was until he moved to Austin. He grew up calling tacos *mariachis*. Tacos were what you had for lunch and dinner. The true explanation for the taco as mariachi in Laredo is not known, but among the theories is that a folded taco looks like the brim of a mariachi's hat.

Adrian grew up eating *mariachis de barbacoa* and *mariachis de papa con huevo* from El Metate and Las Cazuelas, but it was a family-run restaurant in a South Laredo gas station called Chalu Burger that rocked his taste buds forever. The sisters who owned and cooked at Chalu would put a thin layer

of beans on every tortilla so the papa con huevo suddenly became *papa, huevo y frijol*; simple but effective—his go-to recipe to this day.

What is your favorite Austin breakfast taco and why?
Our household's favorite breakfast taco is tried and true: papa, huevo y frijol on a corn tortilla for the wife and flour for the husband and young offspring.

Breakfast Taco Recipe

Follow these directions very, very carefully. Or toss them out the window.

1. First, brew a French press pot of strong coffee before the kids get out of bed.
2. Then, open the refrigerator and pull out a carton of eggs, beans from the Tupperware and your tortillas from the grocery store. (You aren't at your abuelita's anymore. You buy them from the store.)

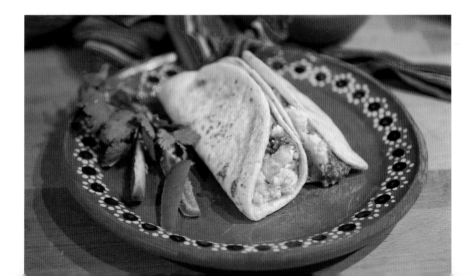

Side Note: If there aren't any eggs, because your family eats about three eggs each a day, walk out to the chicken coop and look for eggs. Tex-Mexicans love eggs like they're the last beer in the football stadium.

3. Depending on the day of the week, either heat the beans in the microwave or heat them in a pot. Same for potatoes. Note: There's a fifty-fifty chance we'll have a big pot of homemade beans or we bought a can from the store. (Add in bacon grease, if your wife is not looking.)
4. Turn on the griddle or comal and start flipping tortillas.
5. Crack open two or three eggs into a bowl and stir in a splash of milk. (If you are at Casita Quesada, it's probably almond milk, and that's perfectly fine.)
6. Turn on the skillet and add a modest-sized slice of butter, about 1 tablespoon. Wait till the skillet is HOT and flash-cook the eggs. Scrape them out while they're still moist and not dry. They'll continue to cook.
7. After everything is nice and warm, spread a thin layer of beans on ye said tortillas and then add a heap of egg and potatoes. Sprinkle cheese and fold tortilla. Try not to take a bite before it hits the plate.
8. Feel free to add steamed greens, tomatoes, aquacate or any veggie. But the foundation is always the holy trinity of: *PAPA, HUEVO y FRIJOL.*
9. *Buen Provecho!*

Tell us about yourself and your connection with Austin...and the breakfast taco.
We started Tipsy Texan in 2007 as a blog after discovering that there was an entire world of cocktail history, and a nascent movement was starting to embrace this and bring it—and that lost art—into today's bartending craft. There's a great deal of overlap between what was happening in cocktails and in the local farmers' market scene through incorporation of the freshest available ingredients. Drinking habits, like eating habits, should adapt to the seasons.

Favorite breakfast taco?
Potato, egg and cheese because it's a vehicle for awesome salsas.

 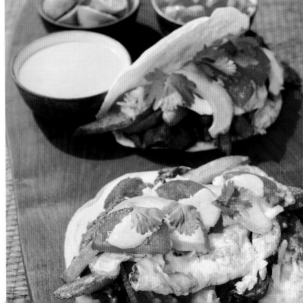

David Ansel, the Soup Peddler

Tell us about yourself and your connection with Austin...and the breakfast taco.

I'm David Ansel, aka the Soup Peddler. I'm from Baltimore, so Mexican food for me as a kid was pretty pathetic. I remember the most common dish being a chimichanga, which to this day I believe is a made-up word. Our Mexican chain restaurant also served fried ice cream, which is of course an age-old interior Mexican tradition. So the Mexican food and Tex-Mex was a revelation when I moved to Texas, and I can now say that I would eat tacos every day if my wife would let me.

The breakfast taco has eclipsed the bagel as the great breakfast food of my life. It's the ultimate. Protein-packed, spicy, lots of great variations, portable, cheap, always a crowd-pleaser. Whenever you need to feed a bunch of people breakfast, it's the only way to go. My introduction was at Maria's Taco Express, which is still beloved to me. However, my heart was won over by a now-closed place called Nueva Onda. When I broke the news to my daughter that our favorite taco place was closing, it was a very touching moment. I said, "Mia, Nueva Onda is going to close, and we will not be able to go there anymore. We are going to go one last time." Her eyes welled up with tears, and she literally stiffened her upper lip and suppressed the wave of emotion. I thought of all the bygone places in my mind, so indelibly etched. I thought of how permanent and formative childhood memories are, that this would

be one of her memories, that it would form in some way what food means to her, what Austin means to her. I wonder if this would be her childhood taco against which all other tacos would be compared. Her tears touched me because they were about impermanence, and I thought, "May this be your greatest loss." As the bygone downtown graffiti on the railroad bridge said, "Life Is Change. Be Flexible." There is really no greater truth. Life is change; permanence is the heart's peculiar folly.

What is your favorite breakfast taco and why?

Egg, potato, bacon and cheese on flour with salsa roja and jalapeño puree (whatever that green stuff is called). That's fluffy scrambled egg, one full slice of thick-cut bacon, hand-shredded (not pre-shredded) cheddar and well-browned individual three-eighths-inch cubes of potato. You have the fresh herb-y sweet fruitiness of the red

sauce; the unctuous heat of the jalapeño sauce; the crisp saltiness of the bacon; the starchy filling-ness of the potato; the pillowy savoriness of the egg; the soft, dry, reassuring warmth of the flour tortilla—pretty tough to beat.

Do you make your own salsas?

I don't have recipes for a verde salsa, but Mando made that green stuff pretty perfect (see below). My personal red sauce recipe is to puree 1 jalapeño with 1 clove garlic and a very large handful of cilantro, then puree in one well-drained 15-ounce can of tomatoes, the juice from half a lime and quite a bit of salt.

MANDO'S "THAT GREEN SAUCE" RECIPE

STEP ONE: *Get yourself a plethora of chiles. I prefer jalapeños, but you can add some poblanos si no eres un macho (ignore the red ones).*

STEP DOS: *Boil 'em till it hurts. The chiles should be nice and limp before you take them out. You can also roast and peel them.*

STEP THREE: *Put 'em in the blender and add the ingredients, which is pretty simple. Salt to taste, and the secret sauce is...canola oil! No, it's not avocados or sour cream or cheese. It's straight up canola oil. That's what makes the salsa crème de la crème.*

STEP FOUR: *Pour it in your favorite bowl and go to town on it! You can also bottle it and try to sell it to H-E-B. I was thinking about it, but who has the time? I got tacos to eat!*

Sazz y Pazz, there ya go!

DORSEY BARGER AND SUSAN HAUSMANN, HAUSBAR FARMS

Tell us about yourself.

DORSEY: *I was in the restaurant business for twenty-four years before I sold my restaurant to become a full-time urban farmer. I am obsessed with raising and growing food using organic, sustainable methods and inspiring other people to grow their own.*

Austin is my connection with the breakfast taco. I'd never heard of them before I moved here in 1985. I thought, "Really? Tacos for breakfast?" And of course they've become just a part of everyday life for me now.

Why I love breakfast tacos.

A tortilla is really the perfect food envelope. It allows me to combine any number of amazing ingredients with a spectacular salsa and, say, cruise around eating one at the farmers' market, looking for more ingredients to throw into my next breakfast taco.

Why do you think Austin loves breakfast tacos?

Austin is linked in so many ways to the culture of Mexico. It influences our language ("Adios"), our dress (huaraches and guayabera shirts) and our food (breakfast tacos). To me, the two cultures are inseparable elements of Austin. Austin loves Mexico. Austin loves breakfast tacos.

What are your top five breakfast taco joints and why?

Taqueria Arandas–because it is so down and dirty! No frills. Great salsa verde. Servers speak mostly Spanish, so I get to practice mine.

Las Manitas (RIP)–OK, I know it's been gone for years, but it will live in my memory forever. The first place I ever ate a breakfast taco. Bacon, egg and cheese was simple and sublime. I miss Cynthia and Lydia, the owners.

Marcelino Pan y Vino–my neighborhood joint. Superb corn tortillas hechas a mano (made by hand).

Curras Grill–Amazing red corn tortillas, unforgettable salsa borracha.

Takoba–Love the tacos, love the patio, love the salsa verde de aguacate.

HausBar Farms' Duck Egg and Nopalitos Tacos

We make these great tacos with duck eggs, nopales, chiles, cilantro and onions all grown right here on our farm. You can find these ingredients, in season, at your local farmers' market.

Make Your Salsa

1 tablespoon corn oil

4 ounces whole chile de Arbol (we use dried red serrano chiles from HausBar Farms)

1 whole garlic clove

½ teaspoon salt

1 cup water

Heat oil in a medium frying pan over medium-high heat. Add chiles and garlic clove and sprinkle with salt. Fry, stirring often, for 10 minutes until chiles and garlic are very brown. Add water (careful, it splatters) and cook chiles and garlic until soft, about 10 minutes. Pour all ingredients, including any remaining water in the pan, into a blender and blend until completely smooth.

Make Some Delicious Handmade Tortillas

Masa (we use El Lago Masa because it is made with non-GMO corn)

Roll masa into balls the size of a large ping-pong ball and press (between two sheets of plastic wrap) in a tortilla press.

Remove flattened masa from plastic and place on a comal or flat griddle over medium heat. Cook one minute on each side until spotted like a tiger on both sides. Hold in a barely warm oven until you're ready to make your tacos.

Taco Construction

½ pound fresh nopales cut into ¼-inch-wide strips

2 cups water

2 tablespoons corn oil

4 farm-fresh duck eggs

4 handmade corn tortillas

5 sprigs cilantro, chopped coarsely

1 spring onion, white and green parts chopped coarsely

Salt and pepper

To prepare the nopales, place them in boiling water in a frying pan. Boil for 5 minutes. Pour into a colander and allow to drain. Return the pan to the stove and heat corn oil over medium heat. Add nopales. Be careful of splatter. Sauté for 5 minutes until they begin to brown slightly. Add beaten duck eggs to the pan with the nopales and scramble.

Arrange eggs and nopales in 4 corn tortillas. Sprinkle with chopped cilantro and onion. Salt and pepper to taste. Top with salsa and devour.

Tell us about yourself and your connection with Austin...and the breakfast taco.

I am originally from Birmingham, Alabama. I had to move around a bit before I finally (accidentally) landed in Texas in 2008. I lived first in Dallas, and I loved Texas from the get-go. There seems to be a lot of competition between some of the bigger Texas cities, but I love them all for different reasons. I fell in love with real Tex-Mex and the plentiful authentic Mexican food right away. People really know good barbecue and Mexican here in Texas, and those are well known to be the most important food groups. I fondly remember the first time I had a real taco. I was twenty and living on the south side of Birmingham when a more adventurous friend of mine decided we should go for tacos to this place that doubled as a Hispanic restaurant and dance club. Up to this point, I had decided that I hated tacos because my only experience with them was the Taco Bell–style fare. These tacos were different. These were real tacos. Slow-cooked barbacoa with fresh onions and cilantro on just-made corn tortillas.

Oh. My. God. My world was changed forever, and if you can remember your first real taco, I think you know exactly what I mean.

I became obsessed with tacos and have been on my own personal mission to create the perfect taco (which will probably just be some version of that first taco). I've made everything from mashed potato and fried chicken tacos to berry-banana dessert tacos and everything in between. My favorite standby is to have my homemade black bean guacamole with some crockpot chicken on a fresh flour tortilla.

What is your favorite Austin breakfast taco and why?

But I digress. I am supposed to talk about Austin and breakfast tacos. Before I moved to Austin, I came here with a couple friends of mine (including aforementioned adventurous friend), and we did our own taco and kolache tour of Austin, which (if you know Austin, you know) was amazing and made us so ridiculously full and happy at the same time. There are a multitude of spots in Austin for great tacos. Some of my favorites include the original Torchy's, Tacos 'N Tequlia and La Moreliana meat market. But, hands down, the best breakfast taco in Austin has got to be the Otto from Tacodeli. This taco is all the most delicious things about breakfast tacos with no filler. Refried black beans, avocado, bacon and jack cheese. I'm getting hungry just thinking about it, aren't you? Of course, I have to drench it in hot sauce. I'm pretty picky about my hot sauce, especially since I make my own, but Tacodeli has a really awesome and addictive habanero sauce as well. I don't think they sell it in stores, and that works out well for me because they'd give me a hell of a run for my money!

BREAKFAST TACO RECIPE

My favorite breakfast taco to make at home is a simple bacon, egg and cheese taco. The only secret to this recipe is how it is prepared. For three tacos (I'm a hungry guy), I start with six pieces of bacon and three eggs. I heat up a cast-iron

skillet to medium and cook the bacon till it's nice and crispy. While the bacon is cooling, I sauté three chopped-up Serrano peppers and three large minced cloves of garlic in the bacon grease. As the garlic and peppers are sautéing, I crack the eggs into a bowl and scramble them. To the eggs, I add a little bit of salt and cumin. When the garlic is golden but not burnt, I add the eggs and cook them, while stirring, until they are just cooked but still soft (nobody likes an overcooked egg). I scrape the egg/pepper/garlic mixture into a bowl and stir in a handful of grated sharp cheddar cheese. I stir the cheese in right after the eggs are done cooking because it gives it the perfect amount of melt without burning the cheese. While I'm doing all this, I heat up three tortillas in another pan. Every tortilla gets two pieces of bacon and a third of the egg mixture. I then smother these in hot sauce and enjoy with hot French press coffee. And THAT is how you start your day in Austin!

HOOVER ALEXANDER, HOOVER'S COOKING

Tell us your story.

I am a native Austinite, having grown up in East Austin. My family came from rural Central Texas—Utley, Pilot Knob, Manchaca (which __was__ rural ranch land in their time). I am a fifth-generation Texan. I went to Our Lady of Guadalupe in East Austin from first to eighth grades and had a great multicultural culinary start in life, eating a lot of home cooking at friends' houses—Mexican-Americans, Cuban American, blacks and Anglos. Breakfast tacos were eaten often and with every possible

combo of meat and eggs; potato and cheese sometimes. At home, we stretched our food budget with fried spam and egg tacos.

What is your favorite breakfast taco and why?
My favorite breakfast taco is the Carne Guisada from Mi Madre's. It seems like such a "luxury" taco to spoil yourself with—chunks of steak, tender, flavorful. It also reminds me of those southern pan-fried cuts of meat my mother would make. She would add a little flour to the pan and make gravy from the drippings.

BREAKFAST TACO RECIPE
This taco recipe is my favorite standby. I grew up eating Southside (Elgin) Market sausage. I love chopping it up and frying to get it a little crispy, along with some home-fried potatoes with onions. I then crack two eggs (often unscrambled) and let them cook in the pan with the mixture. I divide the mixture into two flour tortillas, add some cheddar cheese and roll!

Tell us about yourself and your connection with Austin...and the breakfast taco?

JODI: *I was born in Canada and grew up in the suburbs of Washington, D.C.; it wasn't until I moved to Austin in 2003 that I became a regular breakfast taco eater. I started my local food and travel blog, Tasty Touring, in 2008.*

Early on, I discovered Las Manitas on Congress. Las Manitas was owned by two sisters, and the corn tortillas were made from scratch, in house. It was a gathering place for everyone in Austin–politicians, blue-collar workers, students, celebrities–all types of people went there. My regular order was their Migas con Hongos–scrambled eggs with broken corn chips, huitlacoche mushrooms and melted cheese served with black beans and fresh tortillas on the side. I always asked for more tortillas, which they would deliver, begrudgingly. Those babies were made by hand, one by one–they had a staff member whose entire job during service was to make them on the grill. Las Manitas closed in 2008 to make way for a new downtown hotel–and when it did, it left a hole in Austin's breakfast taco scene (and my heart) that has yet to be filled.

ADAM: *I grew up in Houston where there's no shortage of breakfast tacos, but it wasn't until I moved to Austin in 1994 to go to the University of Texas that I discovered that a simple breakfast staple could rise to the level of holy sacrament. I love taking road trips to Central Texas BBQ joints, swimming holes and live music venues, and there's always a taco place to stop off along the way. I've always said the*

tortilla is the perfect food delivery vehicle, and Austin is the best place in the world to experience all the humble taco can be.

What is your favorite Austin breakfast taco and why?

JODI: *Other than Adam's, my favorite Austin breakfast taco is the Otto at Tacodeli: refried black beans, bacon, avocado and Monterey jack cheese on a corn tortilla with their doña sauce (pureed roasted jalapeño peppers, garlic, oil and salt). Another taco place I love is El Primo on South First, just north of Live Oak Street. Order the al pastor or carnitas taco if you're there for lunch or dinner, and be sure to give it a squirt of their roja salsa for a delicious added kick. You'll need cash here, and it also wouldn't hurt to dust off that high school Spanish as you order, por favor.*

ADAM: *With all the great taco spots around town, my favorite is still waking up on a weekend to see what tasty vittles are waiting in the fridge that we can turn into breakfast. Whether it's leftover barbecue brisket or just garlic, jalapeño and veggies, we cook it up with some eggs, and it makes for a pretty good morning. Any self-respecting Austinite always keeps tortillas and eggs around the house for this very purpose—but if we've got no fillings around or are just feeling lazy, Tacodeli is a favorite spot to start the day.*

BREAKFAST TACO RECIPE

ADAM: *I don't remember when I started making my famous black beans with chipotle sauce, but they've always been a big crowd-pleaser and I've kept them top-secret—until now. I hope that you enjoy the flavors I've had the pleasure of sharing with my friends over the years.*

ADAM'S FRIED EGG TACO WITH AVOCADO, CHIPOTLE SAUCE AND BLACK BEANS

Sauce Ingredients

1 chipotle pepper from canned chipotles in adobo sauce
2–3 teaspoons adobo sauce
2–3 heaping tablespoons mayonnaise
4–6 cloves garlic
Juice from ¼–½ lime
Coarse black pepper and kosher salt, to taste
Cilantro to taste
2–4 tablespoons stock

Black Beans Ingredients

2 dried chipotle peppers
15-ounce can black beans
6–8 cloves garlic, rough chopped
Cumin, to taste
Coarse black pepper and kosher salt, to taste
Chopped fresh cilantro, to taste
Queso fresco

Taco Ingredients

1 tablespoon butter or olive oil
4 large eggs
Coarse black pepper and kosher salt, to taste
2–4 tortillas
1 avocado, pitted and sliced

To make the sauce, place all ingredients in blender and mix. You'll need to taste it and adjust to get the desired consistency and flavor. Smoked turkey stock is my favorite, and I keep it in cubes in the freezer, but I imagine chicken stock would work fine.

To make the beans, reconstitute the dried chipotles in hot water for a few minutes, remove the seeds and chop. Heat the beans, garlic and chipotles over medium heat. When the beans are warm, add cumin, and as they continue to heat, add salt, pepper and any other spices to taste. Take off the heat when the beans have softened, mix in the cilantro and serve topped with fresh cilantro and crumbled queso fresco.

To make the tacos, heat olive oil or butter in a frying pan over medium-high heat. When the oil is hot and fragrant, crack eggs into pan and season with salt and pepper. Cook until you can see that the edges have caramelized and turned crispy. Cover pan with lid, preferably glass, and turn down heat to medium-low. While the eggs are cooking, preheat your choice of corn or flour tortilla, either in a toaster or a lightly buttered pan. Cook eggs until whites are set and yolks start to appear white but are still a bit loose.

Place eggs in the tortilla with sliced avocado and chipotle sauce on top. The beans can be served on the side or rolled into the taco. I like to savor the beans and egg taco separately, but Jodi throws it all in together, so try it out and enjoy your way. You'll want to make a couple extra warm tortillas to sop up any extra yummy yolk that has oozed onto the plate as you're eating the tacos. Serves 2.

Tell us about yourself and your connection with Austin...and the breakfast taco.
I'm a transplanted Hawaii guy who landed in Austin in 1990 and never left. As a kid growing up on the islands, we ate simple rice balls rolled up in seaweed (nori) called musubi. This was the rough equivalent to a breakfast taco back in the '60s and '70s. Later, I discovered the joys of the breakfast taco and adapted it to Hawaiian tastes by adding spam, Portuguese sausage and green onions. Spam goes well with nearly everything, and when combined with scrambled eggs, grilled shrimp and Serrano chilies, the combination is pure Hawaiian goodness.

What is your favorite Austin breakfast taco and why?
One Taco located in a trailer at Fifth and Nueces Street makes the best sausage and fried egg taco I've ever had. The creamy egg yolk combined with the crunch of the sausage makes for a sensory delight followed by wonderful flavors. The coarsely chopped sausage makes this taco feel like a full breakfast rolled in a flour tortilla.

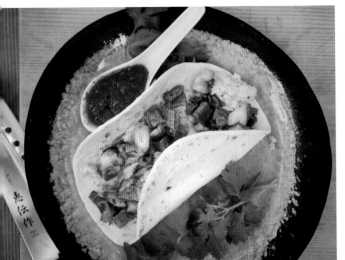

Tell us about yourself.

I'm a born and raised East Austinite with roots in Austin dating back to the early 1900s. I'm the founder/president of the nonprofit Hermanos de East Austin, which focuses on civic and political engagement. I have a deep-seated love for Tejano and Musica Ranchera, namely the "Idolo de Mexico," Senor Vicente "Chente" Fernandez, and have been known to belt out a few songs while in the company of mariachi or any sound system. I am married to the most amazing woman I have ever met who indulges my Chente fanaticism. I have a rescued miniature Pinscher named Chente.

What's your connection with the breakfast taco?

My love affair with the breakfast taco began when I was still in utero, when my mother carried me over one block to "Don Juan's," now known as Juan in a Million, to have breakfast tacos. Being that we have known Juan since he opened his doors, it's still Don Juan's to me. When I was old enough to walk, I was old enough to pull a chair up to the stove and heat tortillas on the comal and fry up an egg with cheese. I've been a tacoholic ever since. There's no helping me.

Why do you love breakfast tacos?

I love breakfast tacos, or all tacos for that matter, because they preclude the conventional breakfast, are a complete meal and are nicely tucked into a compact carrying case.

Why do you think Austin loves breakfast tacos?

Because Austin loves to "keep it weird," cultured and quick.

What are your top five breakfast taco joints and why?

1. Joe's Bakery–they have the best tacos and pink cake, hands down; best salsa. They're in the barrio, and they're familia.

2. Cisco's Bakery–they pile it on, and there is always great political convo in that place.

3. Porfirio's–I've been going there since I was twelve and in junior high, and I would spend all of my lunch plata on breakfast tacos #9s all the time. Nostalgia and the best carne guisada.

With those three...there is no need for a fourth and fifth. VIVA East Austin!

Breakfast Taco Recipe

1 or 2 Serranos, depending on size
Olive oil
2 eggs
Grated cheese (your preference, but it tastes great with either cheddar or swiss)
Flour tortillas, preferably homemade

Preheat a comal over medium heat. Lightly coat your Serranos with olive oil. Put on the comal and let them cook until they start to blacken and the skin begins to peel lightly. Remove from grill and salt lightly. You now have chiles toreados.

Scramble and cook your eggs. Add cheese to the eggs right before they're done cooking so that it melts but doesn't burn.

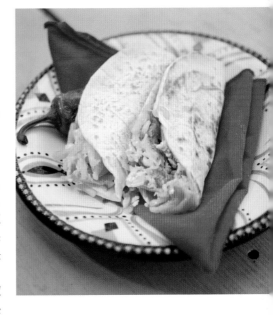

Add all the ingredients to a warmed tortilla and AJUA!

Tell us about yourself.

Though I've lived and worked in Austin for twenty-three years and counting, I consider myself a citizen and son of the Rio Grande Valley, a father to Monica and Maya, a son to Juan Sr. and Maria Elena and a friend to many. I've been a journalist for Texas newspapers and radio for more than thirty years. I am proud of my Mexicano heritage. I'll never be a hipster; I wouldn't know how to begin. If someone didn't know better and gave me tips on how to be one, I'd probably laugh. One of my guiding principles is "Don't forget where you came from." I'm drawn to people who share it.

What's your connection with the breakfast taco?

Breakfast tacos form some of my fondest earliest memories. I'm sure I was eating them soon after I took my first choppy steps, bare-chested and in diapers, there in the heart of the barrio of McAllen, Texas. Later, when I was about twelve and working on pine tree farms in Indiana, I and the other farmworkers would devour them at our midmorning break. For the weary, food never tasted so good. Growing up, breakfast tacos were always around.

Why do you love breakfast tacos?

They are fuel for the soul.

They remind me of home, of family and of our gente. When someone makes a breakfast taco for you, that's love.

They remind me, too, of how our people make do with the simplest, most inexpensive things. Tortillas, eggs, papas. Frijoles.

My favorite taco is as plain as it gets: egg and bean. Sabroso!

Why my favorite? I'm sure it's because my mother would make them for us when we were kids.

Almost fifty years ago, beginning when I was about eight or so, I would help Juan Sr., a barber, at his shop on Saturdays. Sweeping, cleaning windows–that sort of thing. For a barber, Saturdays are moneymakers and pay the bills, and my father would often work till eleven thirty at night. I learned my work ethic from my father, who never complained even when the men who'd had a few at the nearby cantinas would bang on his shop door after he'd locked it at 10:00 p.m. I'm sure they figured that if they banged long enough, my father would open the door and let them in for a haircut. My father almost always obliged.

When we were done, I would follow my father home on my bike. I can remember the sound of the spokes and the rubber tires rolling on city streets, boring through the cool night air. In a small town near midnight, even the major streets were empty, and it was exhilarating for a kid like me to "own them."

When we got home, Maria Elena would make bean and egg tacos for us, and we'd enjoy them around our small kitchen table. My father and I were starved; we hadn't eaten since lunch. I mostly listened as my mom and dad talked about their respective days apart. Again, food never tasted so good. I savored every bite.

Why do you think Austin loves breakfast tacos?

This is a foodie town, but we're not fussy or pretentious about it. Austinites appreciate good food, no matter if it's from a trailer or a four-star restaurant, no matter if it's something they're familiar with or something they've never tried.

Austin is home to a big and fast-growing Latino population, people for whom breakfast tacos have been a staple in their families for generations. For the rest, tacos are becoming as common as cereal for breakfast.

What are your top five taco joints and why?

La Nueva Onda is now closed, but it was my favorite, hands down. The tacos were delicious, and the corn tortillas were quite good, and they welcomed all sorts of new ideas for combinations of ingredients. The owners and staff treated you like family; that was a big part of the appeal.

Curra's. Fresh ingredients. Quality food. Consistently good—they don't have off days. The tacos come piping hot to your table from the griddle, where you can hear the sizzle and the cook chopping, slicing, stirring and turning over ingredients.

Casa Garcia. The chorizo, egg and potato on flour is a meal by itself. Those ingredients complement each other, and the chorizo doesn't overwhelm the overall taste, as it can at many restaurants. This taco will stick to your bones and take care of your hunger at least until it's time for lunch tacos.

San Juanita's. They have a spicy chicken and rice taco that's really good and a combination you won't find at many places. In fact, this taco is good enough to order for breakfast.

El Patio in the Rio Grande Valley. I subsisted on these during my teen and college years. Their homemade flour tortillas added flavor to the taco. Their food recipes, particularly the carne guisada, pollo guisado and shredded beef or picadillo, were outstanding and reminded you of home.

THE RGV "OLD SCHOOL" BREAKFAST TACO #1

Huevos con Frijoles

Frijoles charros (aka refried beans)

4 cups dry frijoles (pinto beans)

1 packaged salt pork, cut in half

1 onion, diced

6 cloves garlic, minced

1 whole Serrano, thinly sliced into 10–12 rounds (half seeds removed)

1–2 teaspoons salt (more or less to taste)

2 teaspoons black pepper (more or less to taste)

2 teaspoons chili powder

2 teaspoons cumin powder

1 cup chopped Roma tomatoes

½ cup chopped cilantro

Manteca (lard)

Rinse beans in cold water, sort out small stones, etc. Place beans in a stock pot with both halves of salt pork. Cover with water by 2 inches, bring to a boil for a few minutes and then reduce to a gentle simmer. Simmer 2 hours under gentle low heat, keeping an eye on water level. (If more water is needed, make sure to add very HOT water.)

After 2 hours, throw in diced onion, minced fresh garlic and sliced Serrano—cover and continue to simmer for 1 more hour. Add salt, pepper, chili powder, cumin, chopped Roma tomatoes and cilantro. Cover and continue to simmer for 30 minutes or until frijoles are tender

and done. In a cast-iron skillet, melt 2 tablespoons Manteca under medium heat. With slotted spoon, transfer cooked charro beans from stock pot to skillet until skillet is moderately full and continue lightly sautéing frijoles in hot Manteca for about five minutes. Transfer some broth to skillet. Begin mashing by hand until frijoles are smooth and creamy. Add a few spoonfuls of cooked frijoles from stock pot to skillet. Set skillet to the side under a very low simmer, awaiting the preparation of the RGV "Old School" Breakfast Taco.

Huevos Revueltos

Tortillas
6–8 eggs, room temperature
2 tablespoons vegetable oil
2 tablespoons butter
Splash of water
Salt and pepper, to taste
Thick-sliced bacon, optional
Shredded Longhorn cheese, optional
Avocado, optional

Warm tortillas de harina on a comal and set aside. Prepare skillet for eggs. Heat mixture of vegetable oil with butter over low/medium heat. Crack all eggs in a separate bowl, add a splash of water and salt and pepper. Lightly beat eggs, water, salt and pepper only until incorporated. Pour egg mixture into hot skillet. Increase heat to medium. Gently stir with a wooden spoon until four-fifths cooked, or to your preference. Turn off heat and move skillet to the side. Take warm tortilla, fill with 2–3 tablespons frijoles refritos and add warm scrambled egg to fill taco to desired fullness. Devour with a bottle of very cold Mexican Coke.

**Tex-Mex Options: place one slice of cooked *thick* bacon on top of eggs and/or top with shredded Longhorn cheese. Or add a slice of avocado. Growing up, we enjoyed simple tacos of eggs with beans, nothing else—but these options kick it up a notch!

Tell us about yourself and your connection with Austin...and the breakfast taco.

My name is Lonnie Limon, and I am a third-generation Austinite born into a family of musicians and small business owners. Both sides of my family have been musicians since the early 1900s in East Austin, and we still run a small dry cleaners (Estrada's) and flower shop (Diana's Flower Shop) on East Seventh Street. It was in East Austin that I ate my first breakfast taco...a bean and egg taco in a homemade flour tortilla made by my Grandma Limon. It was a daily ritual for my family to stop by Grandma Limon's house before work and school. And there, in a small kitchen on Don Ann Street (now Calle Limon), I enjoyed the same bliss every morning listening to my tios and tias yell (I mean talk) about current events and politics while I ate my two bean and egg tacos. Even today, when I visit my great-aunt Julia, who is in her nineties, she asks for a simple pleasure, a bean and egg taco, so I know I share the same pleasure with a family elder. Such simple perfection.

What is your favorite Austin breakfast taco and why?

My favorite Austin breakfast taco is the bean and egg taco in a flour tortilla from Joe's Bakery because it tastes just like my Grandma Limon's and my Great-Grandma Gila's. The smell, the taste and even the texture instantly call to mind family, simplicity and love.

Breakfast Taco Recipe

My mom's carne guisada recipe, which is equally one of my favorites.

Limon Family Carne Guisada Tacos

2 tablespoons oil
1½ pounds boneless beef top round steak, cut into small cubes
1 teaspoon salt
1 teaspoon pepper
1 teaspoon cominos
1 teaspoon garlic power
3 tablespoons flour
4 cups water
½ can Rotel
1 Serrano pepper
Tortillas
Cheese (your preference)

Add oil to a warm skillet. When skillet is hot, add meat and cook until brown. Add salt, pepper, cominos and garlic powder and stir. Next, add flour and mix until flour is brown. Add water slowly and stir into cooked meat. Keep mixing until flour has turned into gravy. Add Rotel and Serrano pepper and mix well. Lower the flame and cover until mixture is desired texture, around 20 minutes. If gravy is too heavy, add ½ to 1 cup of water and simmer another 15 minutes. You can add more water and simmer longer for desired texture and tenderness. Warm tortillas, add some cheese and enjoy!

Tell us about yourself and your connection with Austin...and the breakfast taco.

I'm Austin City Council member Mike Martinez and have been in office since May 2006. I served as an Austin firefighter for thirteen years prior to joining the council and also as the president of the Austin Firefighters Association. I moved to Austin during the summer of 1988 after my first year of college to continue my education. I have been around the Austin area my entire life, with family here since the early '70s. Tacos have been the mainstay of my diet since the first time my grandma's homemade tortilla touched my lips. Making breakfast tacos was one of my favorite times with my grandma, and she is the inspiration for my tacos. She would put just about anything in a taco and make it taste so good. So I took some of my favorite taco items she would use and came up with this one. We used eggs, bacon, cilantro, cotija cheese and poblano peppers to come up with a great little breakfast taco. Miguelito's tacito!

What is your favorite Austin breakfast taco and why?

I would have to say that my favorite breakfast taco is the bacon, bean, cheese and egg taco at Joe's Bakery. I just can't get enough of Joe's breakfast tacos.

Breakfast Taco Recipe

6 large eggs

2 tablespoons water

½ teaspoon cayenne pepper

1 tablespoon butter

1 poblano or aneheim pepper, seeded and diced

Salt and pepper, to taste

4 tortillas, your choice

1 large avocado, cubed

Roasted salsa

1 bunch cilantro, chopped

2 ounces cotija cheese, crumbled

Warm pan on medium heat. Vigorously whisk eggs with water and cayenne pepper; set aside.

Melt butter in pan. Once foam subsides, add diced peppers and season with salt and black pepper to taste. Sauté until soft, about 5 minutes.

Add egg mixture to pan with the peppers and scramble until almost done. Remove pan from heat and scramble another minute until cooked through.

Divide egg and pepper mixture among 4 warmed tortillas. Garnish each taco with ¼ of the avocado, roasted salsa, chopped cilantro and cotija cheese.

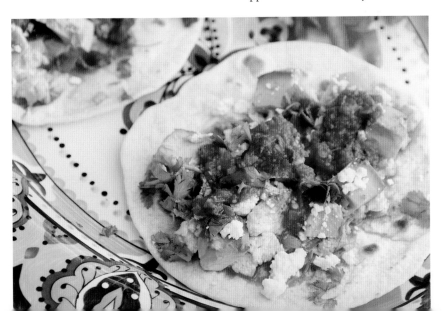

Tell us about yourself.

I'm a technology writer for the Austin American-Statesman *and a few other publications, and I've lived in Texas most of my life. My wife and two daughters keep me pretty grounded. We live in New Braunfels, which has a really distinct culture, even for Central Texas. I'm a fan of good writing, video games and great Texas food.*

What's your connection with the breakfast taco?

I grew up in South Texas, and I don't ever remember a time when there weren't refried bean and cheese breakfast tacos, migas or leftover potato, egg and chorizo tacos on the breakfast table. I remember my dad always making an extra effort to make sure we got barbacoa for tacos on Sundays—along with pan dulce—and it always felt like we were getting a special treat.

Why do you love breakfast tacos?

For me, it's genuine comfort food. They're quick, they're filling, you can put practically anything in them and, with a bit of salsa, they start your day with a little kick.

Why do you think Austin loves breakfast tacos?

A lot of it is geographic, I think. We're close enough to the border that South Texas food culture has really taken over the area. And I think restaurants and even fast-food chains like Whataburger have done a lot to promote the idea of breakfast tacos

and to make them more mainstream. They're perfect quick-and-dirty trailer food, and it sets us apart from other hipster meccas, I think. Austinites love introducing breakfast tacos to visitors who've never had them.

What are your top five breakfast taco joints and why?

Whataburger—consistent and comforting, and I love their little picante packets.

Maria's Taco Xpress—when I lived in Austin, I used to go there and order barbacoa and migas tacos all the time.

Curra's Grill—ditto: another go-to place in Austin that I miss.

Granzin's—New Braunfels place known for its barbecue, but their breakfast tacos, especially the ones with sausage or carne guisada, are amazing.

Magnolia Café—one of the first real restaurants in Austin where I had great breakfast tacos. Everybody has them now, but their huge, stuffed tacos with fluffy eggs and sausage got me through a lot of hangovers in my twenties.

SIMPLE SAUSAGE, EGG AND CHEESE TAQUITOS

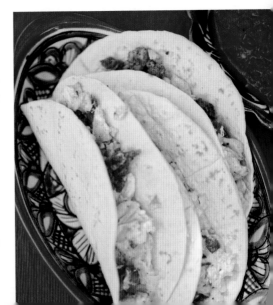

1 roll of sausage (I like Jimmy Dean All-Natural or Maple Pork Sausage, but any kind works fine)

5–6 eggs

½ teaspoon salt

½ teaspoon pepper

1 teaspoon paprika

8 corn or flour tortillas

Salsa or hot sauce of your choice

½ cup shredded cheese (cheddar, American or any Mexican style you prefer)

Liberate about half of the sausage roll from its container and roll it into small, ½-inch balls or crumbles and cook on a skillet over medium heat until browned. Put aside.

Crack eggs in a bowl and add salt, pepper and paprika. I like lots of paprika, but you may prefer a little less. Scramble the eggs and begin cooking on a sprayed or oiled pan over medium heat.

Add the sausage to the eggs once they're cooked, and mix well.

Cook the tortillas until they're brown and firm and fill them with your egg/sausage mix. Add salsa and cheese and enjoy!

PAUL QUI AND DEANA SAUKAM, UCHIKO/QUI/EAST SIDE KING

Tell us about yourself and your connection with Austin...and the breakfast taco.

PAUL: *I moved to Austin from Houston to go to culinary school. I ended up working at Uchi and stayed in Austin and started my restaurant East Side King and am now working on Qui. The breakfast taco was a college staple for me. It's cheap, fast and satisfying.*

DEANA: *I moved to Austin from Houston to attend the University of Texas. I fell in love with Austin and haven't left...I have been here for thirteen years. I have had so many delicious breakfast tacos since being in Austin, and I am pretty sure a few*

breakfast tacos have saved my life after a few not-so-sober nights out. Our breakfast taco recipe is a healthier version of the ones I remember eating in college, which is great since I'm getting older and gravity is taking over.

What is your favorite Austin breakfast taco and why?
Since doing the photo shoot for this book and learning about Joe's Bakery, their migas taco has been my favorite. Thanks, guys!

Another favorite breakfast taco is anything from El Primo. Pete's Tantalizing Tacos from Maudies are pretty delicious, too.

BREAKFAST TACO RECIPE

Salsa
1 medium white onion, diced
1 head garlic, peeled
2 jalapeños with seeds, sliced thin
Grape seed oil
4 medium tomatoes
Juice of 8 limes
Salt and black pepper, to taste

Sweat onions, garlic and jalapeño in enough grape seed oil to coat the vegetables on low heat. Cook until the vegetables are soft but uncolored. Once cooked, place in a blender or food processor with tomatoes and lime juice, and season with salt and pepper to taste.

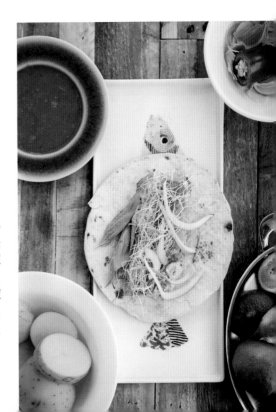

Torta (Egg)

1 shallot, julienned
4 garlic cloves
1 tablespoon butter
1 teaspoon grape seed oil
2 small potatoes, small diced
4 large farm eggs, scrambled
Sea salt, to taste
Buttermilk tortillas
2 ounces Greek yogurt
1 container alfalfa sprouts
1 bunch basil

In a medium-sized pan on medium heat, sweat shallots and garlic in the butter and oil and add the potatoes. Once alliums are translucent and potatoes are light brown, add the eggs and season with salt to taste. Cook the eggs until set but not too dry.

Toast the tortillas. Assemble as follows: tortilla, torta, yogurt, sprouts, basil, salsa. Place as much or as little filling as desired. Serves 4–6.

SARAH HICKMAN, MUSICIAN

Tell us about yourself and your connection with Austin...and the breakfast taco.

I'm one of the official state musicians of Texas, so it would be a sin if breakfast tacos weren't my favorite meal of the day!

My first breakfast taco was in Austin at the eclectic Las Manitas in 1995, when I arrived from Dallas. Las Manitas was a neighborhood community of Ann Richards to Charlie Sexton, people from around the globe gathered in booths,

chowing on delicious breakfast tacos. Since then, I've introduced breakfast tacos to other folks when I am out on tour, if I happen to be staying in their home. I'll make those suckers up morning, noon or night. It's a simple, creative meal and easy to travel with, as well. And, seriously, who can eat just one? Can you? I didn't think so.

What is your favorite Austin breakfast taco and why?

I love Tacodeli! When they first came on the scene (ten or eleven years ago?), they had the best surfer-looking guys working at their one location on Spyglass, a sort of secret location one had to be in the know to visit. All their ingredients are super fresh, they have a wide variety and I love their hot avocado salsa. However, I have to give a shout-out to my husband, Lance, for homemade breakfast tacos...He uses all sorts of yummilicious ingredients, and they are hot from the kitchen while we sit at the bar and chow them down. We use Papa Perry's Pepper Products to plop on top. Really tasty, wild flavors–peppers mixed with pineapple, watermelon rinds, cantaloupe.

When you make breakfast tacos, what are your favorites?

I love eggs, cheese, jalapeños, mushrooms, lettuce, avocados, black refried beans and TONS of salsa dripping all over. I have a side of bacon and hot coffee with cream. I like a breakfast taco stuffed to the hilt, like they make at Kerbey Lane.

Tell us about yourself and your connection with Austin...and the breakfast taco.

Karrie and I moved to Austin in 1996 to start up the Alamo Drafthouse. We were able to cobble together about $250,000 to build the first theater, but that left us almost zero cash to exist. We couch-surfed for about six months with my saintly cousin Mary and tried to make our food dollars stretch as far as we could. For the entire year leading up to the opening of the theater, we spent a grand total of $5,000 on all of our combined living expenses.

What is your favorite Austin breakfast taco and why?

Almost every single day after working past midnight on the construction, we would drive to the Taco Cabana on Lamar and Riverside on our way home. We would order one chorizo and egg taco and an extra tortilla. We would divide the filling between the two taco shells and then overload it with the pico and salsa from the self-serve bar. That gave us a late-night dinner for two for about $2.50, which we ate probably four nights a week for six months.

Although Taco Cabana probably isn't the hippest choice for favorite breakfast taco, I still think they are pretty great, especially by fast-food standards. Every single time we go back to Taco Cabana, the nostalgia of building the very first Alamo Drafthouse washes over us. For that, it remains my favorite breakfast taco in town. I guess you could say their chorizo and egg tacos were the fuel that built the first Alamo Drafthouse.

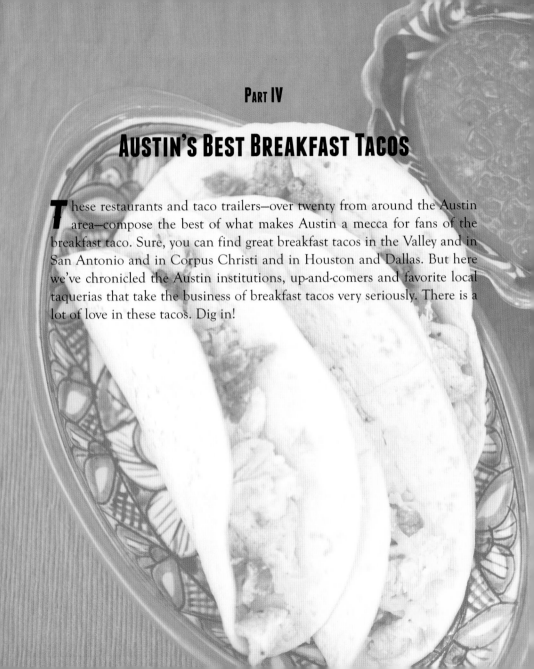

PART IV

AUSTIN'S BEST BREAKFAST TACOS

These restaurants and taco trailers—over twenty from around the Austin area—compose the best of what makes Austin a mecca for fans of the breakfast taco. Sure, you can find great breakfast tacos in the Valley and in San Antonio and in Corpus Christi and in Houston and Dallas. But here we've chronicled the Austin institutions, up-and-comers and favorite local taquerias that take the business of breakfast tacos very seriously. There is a lot of love in these tacos. Dig in!

BREAKFAST TACO MAP

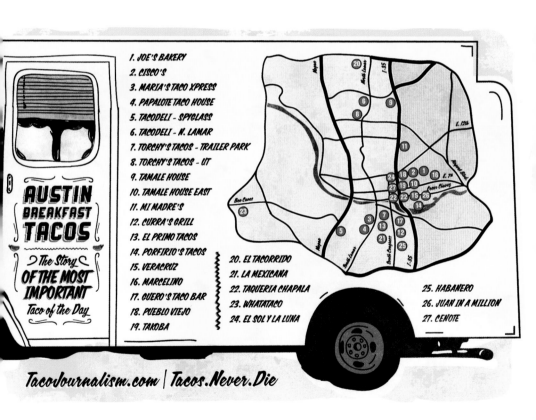

1. JOE'S BAKERY
2. CISCO'S
3. MARIA'S TACO XPRESS
4. PAPALOTE TACO HOUSE
5. TACODELI - SPYGLASS
6. TACODELI - N. LAMAR
7. TORCHY'S TACOS - TRAILER PARK
8. TORCHY'S TACOS - UT
9. TAMALE HOUSE
10. TAMALE HOUSE EAST
11. MI MADRE'S
12. CURRA'S GRILL
13. EL PRIMO TACOS
14. PORFIRIO'S TACOS
15. VERACRUZ
16. MARCELINO
17. GUERO'S TACO BAR
18. PUEBLO VIEJO
19. TAKOBA

20. EL TACORRIDO
21. LA MEXICANA
22. TAQUERIA CHAPALA
23. WHATATACO
24. EL SOL Y LA LUNA

25. HABANERO
26. JUAN IN A MILLION
27. CENOTE

AUSTIN BREAKFAST TACOS

The Story OF THE MOST IMPORTANT Taco of the Day

TacoJournalism.com | Tacos.Never.Die

RESTAURANTS AND RECIPES

Tell us your story.

Cody Symington and I [Mary Jenkins] live in the neighborhood, and after working in the restaurant industry for years, we decided we wanted to open our own place. We had a friend in town who was staying with us, and he asked us if there was a place within walking distance to get a good cup of coffee and breakfast. The lack of options in our neighborhood got us thinking, and we started looking for a space to open a coffee shop on Cesar Chavez. We found 1010 East Cesar Chavez, which was for sale, advertised as a tear-down ("The value is in the land!" the ad said). We took a look at the property, which housed an old farmhouse, which was built in 1893 (and added on to quite a bit throughout the years), and a small duplex apartment building. We fell in love with the house and immediately began trying to figure out how to purchase it and turn it into a coffee shop. With the help of investors and several other co-owners (Cody's father Nick and brother Cully and our good friend Heather Lubovinsky), we made it happen and proceeded to spend the next two years wrangling with city code and red tape while trying to make our vision a reality. We opened our doors March

25, 2012, to a group of excited neighbors. Our original food menu was just pastries and bagels. For those first couple of weeks, many customers and neighbors requested a more extensive food menu. Cody had worked with Arturo Lopez at Jack Allen's kitchen and contacted him for help in finding a solid kitchen staff. At the time, Arturo had left Jack's and was working at another place that he wasn't happy with. Instead of finding us a kitchen staff, he took the job on himself. Arturo enlisted the help of his wife, Lucia, who began making us tortillas from scratch every day. We focused on using high-quality ingredients and local ingredients, depending on what was in season. People responded positively to Arturo's food, and things took off from there. We just celebrated our one-year anniversary and are very happy with how Cenote has evolved.

What is your most popular breakfast taco and why? What makes it stand out?
Our most popular breakfast taco is the bacon taco. We get our bacon from Jerry of Flying Pig Provisions. His bacon is incredible!

Why do Austinites love breakfast tacos so much?
I think the breakfast taco is Austin's best comfort food. They are delicious and easy to come by and almost always taste good, no matter where you get them. Not to mention a great hangover cure...

Breakfast Taco Recipe

2 homemade corn tortillas, doubled up
Scrambled eggs from Coyote Creek Farms
Shredded cheddar and jack cheeses

Your choice of the following:
Potatoes
Homemade chorizo
Flying Pig bacon
Avocado (if you're feeling fancy)

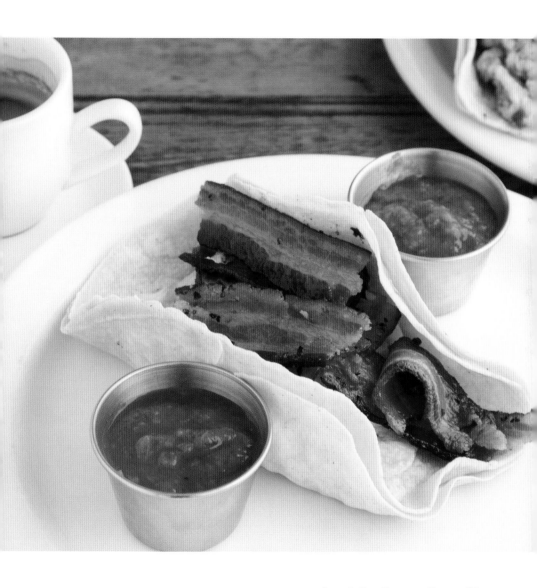

What is the history of the business, and what is your personal story with the business?

There's a story about Clovis's dad, Rudy, also known as Cisco, the man who made huevos rancheros famous. He was best friends with Lyndon B. Johnson back in the day, and when he made office and he went to the White House, there was no Mexican food there, so he would call Rudy: "Hey, send the ranchero sauce cuz there's no Mexican food here." That's the saying. The man who made huevos rancheros famous because he had to have ranchero sauce for his eggs.

The restaurant actually started...well, the sixth generation is running it here. The first generation was his grandfather, who started in the '20s in another building across the way, and it was just a little bakery. And then when Rudy took it over, he moved it to another restaurant across, and it was Pan Dulce, and they started serving breakfast with the huevos rancheros and the Bloody Marys because where else could you get a Bloody Mary at seven in the morning?

We make biscuits fresh daily, and you just gotta have biscuits! Those big, fluffy buttermilk biscuits. What would we do with the butter and honey if we didn't have biscuits anymore? You gotta have something to put the butter and honey on!

The biscuits and the bolillos are the only things we bake anymore because they're very, very popular. The bakery used to serve bread all over town back in the day. They've got a great big

industrial oven, and they would serve the Driskill their bread. And that's how they started, basically. Clovis, he grew up delivering bread and started working here when he was like eight years old washing dishes. Yeah, it started off as a bakery, and as time went by, they were throwing away more pan dulce than selling, so...you know.

The history and everything about our business is really all about a family atmosphere. People tell us stories about the restaurant: "When I was a little girl, my grampa..." It's really neat. And so it's just keeping it the same format. You can't change the flavor. You don't want to make any changes. You want to keep it the same. We even have to watch out how much we remodel because it would change it too much. They want the memories of all the old pictures on the wall...everything like that.

There are the spirits walking through, too...Oh gosh, there's all sorts of them here. In the morning. Like I've seen...like I've seen Rudy. Clovis would say, "Hey, is there anyone else in the back before I close out the register?" and I would catch his spirit in my peripheral. We'll be cleaning and have the music playing, and you can hear him dancing. You'll get to the point where you can hear the chairs moving and everything. It's almost an everyday thing. If they want you to know they're there, they'll let you know. There's a whole number of people. There's a lady; there's a guy in the back.

What is your most popular breakfast taco and why? And what makes it stand out?
I would have to say the migas, the migas taco because they're so fat. They have everything in it. Good cheese, it's got the eggs, the onions, the tomato—it's just how our cooks make them. I mean, that's all it is. I mean, we give them a good taco. You know, for the price, you can make two tacos out of one of our tacos. A lot of time people will order a third, and I'll look at them and say, "You sure you want to order a third taco? That's a lot of food!" And I've made bets with people and won. I bet you can't eat them all...you can try.

Why do you think Austinites love breakfast tacos so much?

Because everybody's in a hurry to go somewhere. It's easy to grab a taco and go. And you can have it fresh, made the way you want it. A lot of places you can't get it that way. Like, this is what we've got and it's already pre-made, so pick one. A lot of people want to be able to come in or to call in, stop on their way to work and then, boom, they're gone because I mean, to tell you the truth, everybody is in a hurry to get somewhere. It's a college town; either they've got to get to class or their business appointment. A lot of people end up staying here. They end up doing their business here. Well, we've got everybody here for the meeting, why don't we just sit right here? And the atmosphere is so comfortable.

Breakfast Taco Recipe

What makes our migas tacos different is that they are made to order. A lot of times when you go somewhere, everything's already pre-made; you can't special-order them— with no onions or no cheese. You can add chorizo to it. That's one of my favorite migas. Throw some chorizo in there. Yeah, and some onions and jalapeños. And I have people doing migas with the chorizo and potatoes, and they add the kitchen sink. And it can't even fit in the tortilla, you know. And drown it with ranchero sauce. Here's our version.

Cisco's Migas Breakfast Taco

On a warm skillet, add a little bit of oil and then cook tomatoes with chopped onion. Once this is sizzling, add an egg. The last to go in are the cheese and chips. Warm up a tortilla and serve.

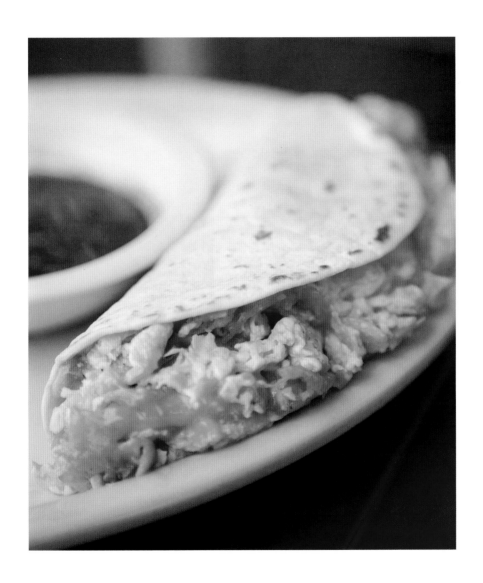

JORGE GARCIA, CURRA'S GRILL

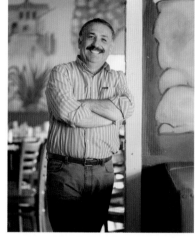

Tell us your story.

Curra's Grill was founded by the Garcia family back in 1994. My parents wanted to move to the States and start a small business, so my brother and I suggested a small restaurant. Who would know that it would become one of the top Mexican restaurants in the nation?

What is your most popular breakfast taco and why? What makes it stand out?

Chorizo and egg. We make our own chorizo; we grind our pork meat after trimming all the fat off the meat. This allows a great chorizo taco not to be greasy.

Why do you think Austinites love breakfast tacos so much?

Austinites love a fresh made-to-order breakfast taco—a great meal that can supply high carbs, protein and are full of flavor, plus they can be vegetarian or gluten free, as we now offer a blue corn tortilla (gluten free).

Potato, Bacon and Egg Breakfast Taco

Always use fresh ingredients!
Precook bacon, remove all grease.
Precook potatoes using canola vegetable oil.
Heat up the bacon and potatoes and add eggs, cooking or scrambling till done.
Use flour or corn tortillas.

Tell us your story.

My name is Jose Luis, and I am the owner of El Primo on South First. I am from Michoacan and came to the United States about fifteen to twenty years ago. I lived in Chicago for about ten years, where I worked for my uncle for about five years and learned the business from him and started my own. I got married there, but my wife didn't like the cold, so we decided to come to Austin. I first opened the Burrito Factory across the UT campus. I saw that there weren't a lot of people in the summer, so I decided to buy a taco stand because they were becoming popular around Austin. El Primo has been open for eight years now.

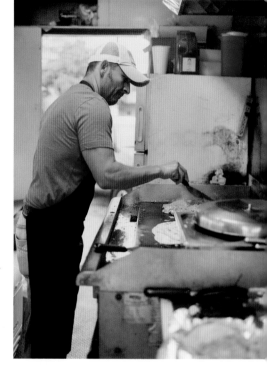

I didn't know how to make a breakfast taco at all; in Chicago, they don't sell breakfast tacos. In Mexico, the breakfast taco doesn't exist—maybe on the border, but not in South or Central Mexico; instead, we have breakfast plates. When I got here, my wife tried a breakfast taco and didn't like it, and when I started making her my own taco, she said, "Now these are good!"

The name El Primo is because my wife's cousin worked with me, and we would always say, "Primo [cousin] this, primo that and primo that," and everyone would call us primo. Because everyone was gringo at the UT location,

I called it Burrito Factory, but because on First it was Latinos, I gave it the name El Primo.

Originally, 80 percent of the customers at El Primo were Latino. Today, the same Latino customers continue to come, but Anglos now make up 60 to 70 percent of the customers. Our tacos have also become very popular because of the coffee shop next to me, Once over Coffee. I am in their menu, and when you go on Facebook, it says go buy tacos from El Primo, that they are very yummy. We both say, "If you weren't here, I wouldn't be here either."

What is your most popular breakfast taco and why? What makes it stand out?
My migas is very popular, or the chorizo that I make. People tell me that the secret behind the tacos is the red sauce I make myself; it gives it a lot of flavor. I learned how to make the sauce from my uncle. When I got here, I thought they wouldn't eat so spicy, so I added my own ingredients to my uncle's recipe to reduce the spiciness, but it gives it more flavor and texture.

Why do you think Austinites love breakfast tacos so much?
I really don't know what has made the breakfast taco so popular. When I first opened on First Street, it was just me and Torchy's Tacos. Now, no matter where you go, you can find one. At first, there were like one to two hundred food trucks; now there are over a thousand, and not just breakfast tacos but all kinds.

Chorizo, Egg and Cheese

Cook chorizo on a hot griddle for about 3 minutes, or more if you prefer. Pour the egg on the griddle and mix with the chorizo until it makes an omelet and then scramble. Heat up the tortilla until warm. Add cheddar cheese on top of the egg and chorizo until it melts, and wrap it all inside the tortilla.

Migas Taco

Place cilantro, onion and corn tortilla chips on a hot griddle and heat until crispy. Add eggs and ham to the ingredients on the griddle until it makes an omelet and then scramble. Heat up a flour tortilla and wrap the ingredients into the tortilla.

Nilda de la Llata is the majority co-owner of El Sol y la Luna. Through her leadership from 1995 to 2008, El Sol y la Luna has been one of the most popular and successful businesses of the South Congress revitalization. While other more trendy restaurants have come and gone, El Soy y la Luna has substantially grown, having the need for a bigger venue. Thus, it relocated to the corner of Sixth Street and Red River—where it will continue to offer local, tourist and celebrity customers alike the same charm and delicious fare that compel most to return for more.

In keeping with her philosophy that hard work is the basis for everything worthwhile, it occurred to Llata that she could work just as hard and do more than just make ends meet. She opened her own restaurant that combined three of her passions: food, music and art. To that end, El Sol y la Luna does its part to promote local artistic and musical talent and doubles as a gallery and stage that features live music and local art for sale. The rest, as they say, is history.

Llata accepts the challenge of running a business with aplomb and creativity. Employees are considered family and encouraged to develop their business focus to empower their own life situations. She can be found daily at the restaurant modeling to her employees how to ensure that guests enjoy the restaurant's authentic interior Latin American food and ambience to the fullest. Her employees greet and serve customers with grace, immediacy and pleasantness. To date, most of El Sol y la Luna's original employees remain, and two have opened their own restaurants.

Without exception, Llata works tirelessly to elevate women's status as business owners and to educate a predominantly male vendor industry about women's business acumen. She defies the notion that girls and women, especially Hispanic women, cannot conduct successful business transactions.

Llata's success is evident in the local and national recognition she regularly receives. El Sol y la Luna has consistently been voted one of the fifty best Hispanic restaurants in America by *Hispanic* magazine and has been featured in many publications and media, including the *Austin American-Statesman*, the *Austin Chronicle*, the *New York Times*, *Gulliver's Travel*, *Elle Décor* magazine, Southwest Airlines, Continental Airlines, Univision and in an upcoming feature in *Latina* magazine. Llata was selected Woman of Year in the Arts by the YWCA of Austin in 2005.

Not one to take her success for granted, Llata is a staunch supporter of the community. She donates her time, in-kind resources and financial support to many local nonprofits, including SafePlace, Leadership Austin, the Austin Public Library Foundation, Martin Middle School, YWCA of Greater Austin, Austin's Chapter of ALLGO, Las Comadres, Caritas of Austin, El Buen Samaritano and the Chautauqua River School, to name a few. She has been a member of the Mexic-Arte Museum Board of Directors for eight years, two of which she served as president. She has been instrumental in the evolution and success of Mexic-Arte Museum as the official Mexican and Mexican American Fine Arts Museum of Texas.

What is your most popular breakfast taco and why? What makes it stand out?
One of our bestselling tacos here at El Sol y la Luna is our Vegetarian Chorizo made in house from organic soybeans, chiles and spices. With Austin being a very healthy-oriented community as a whole, it is not a wonder why this vegetarian chori miga taco is one of our bestselling for breakfast.

Why do you think Austinites love breakfast tacos so much?

Austinites love breakfast tacos because they are delicious, trendy, fast, healthy and inexpensive. There are so many varieties of ingredients that can go into breakfast tacos, making it appealing to each individual's taste buds. Eating tacos is not just for Latinos. It has reached out beyond our culture, becoming a multicultural trend.

VEGGIE CHORIZO MIGA TACO

Our veggie chori miga taco is prepared the following way and served on a corn, flour or whole-wheat tortilla.

Veggie Chorizo
1 pound soy
15 Cascabel chiles
1 bulb garlic
¼ onion
1 tablespoon marjoram
1 tablespoon thyme
1 tablespoon oregano
1 pinch salt
2 cups vegetable oil
1 cup apple vinegar

Let the soy rest in hot water for 2 hours. Boil the rest of the ingredients. Liquify and then strain. Mix the strained soy with the salsa.

Tell us your story.

Guero's Taco Bar was opened in 1986 by Rob and Cathy Lippincott. We opened in a small strip center on Oltorf, had seating for about fifty and employed three people. Nine years later, we were fortunate enough to purchase the location of the Central Feed and Seed Store at 1412 South Congress. We renovated and remodeled, and here we are today. Now operating as a South Austin Mexican restaurant for twenty-seven years! Still family owned and operated.

What is your most popular breakfast taco and why? What makes it stand out?

We have always made breakfast tacos...from the traditional ingredients, like egg, potato, cheese and bacon, to our now popular vegetarian options, which include a

popular soy chorizo. Our corn tortillas are lovingly handmade all day long and are a perfect pairing with our breakfast choices.

We are proud to serve a Taco Ricardo as a unique choice for a breakfast taco. It is named after a customer who wanted us to put his favorite taco on our menu. It is best served on a freshly made corn tortilla and then topped with seasoned and grilled chopped pork. We finish it all with an egg fried to order and topped with Guero's salsa ranchero.

Why do you think Austinites love breakfast tacos so much?

I can remember the first time I ever had a breakfast taco. I was a schoolteacher on the west side of San Antonio in the mid-'70s, and the ladies in the kitchen were making them for all the teachers. It was love at first bite. I guess it was to be my destiny!

Taco Ricardo

Thinly sliced pork butt, seasoned and grilled...then chopped into small pieces and stacked on top of 1 handmade corn tortilla.

Fry an egg to order (easy to medium is best so the yolk can run into the pork). Then top it all off with Guero's salsa ranchero and grated cheese. Wonderful when served with refried beans and grilled potatoes on the side.

Tell us your story.

We come from a family of Mexican restaurants. Dos Hermanos was previously in Habanero's spot. It was my father, Arturo, the owner's father and uncle. They decided to sell the business and offered it to my father, Arturo. At the time, we were living in a small eastern town in Oregon and had a small tortilla factory there, but Arturo jumped at the chance of moving to Austin and bought the restaurant from his family. Arturo became the owner of the newly named Habanero in July 1999. Speaking for myself and Arturo, it is our life, and we fully intend to put our all into the food that is made and intend to keep it that way for many, many years (hopefully!) to come.

What is your most popular breakfast taco and why? What makes it stand out?

Our most popular breakfast taco is going to have to be the migas taco. Migas is a staple of Mexican breakfast. It is legit Mexican breakfast food. Throw that into a portable breakfast, aka a taco, and you got the perfect entrée! We make our migas taco to order. We quickly sauté the veggies that go into the migas, which brings out the vibrant colors and flavors that go into such a great thing!

Why do you think Austinites love breakfast tacos so much?

Austinites are a unique breed; therefore, we are passionate about the things we love. Breakfast tacos are such a convenient, fast yet complicated thing. When eating a taco, you don't have to just settle on one; you can have a few and get your fix. For some reason, they always help with a hangover.

BREAKFAST TACO RECIPE

We start with crisp corn tortilla pieces and add sautéed onion, tomatoes and jalapeños. Mix in an egg. When everything is almost perfectly combined, we add a heaping amount of cheese and let it melt. Then put it in either a corn or flour tortilla.

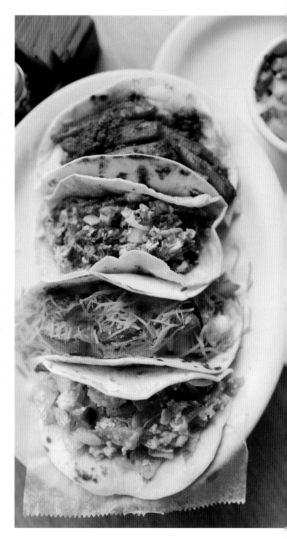

Pauline Avila, Rose Ann Maciel and Regina Estrada, Joe's Bakery & Coffee Shop

For over seventy-five years, Joe Avila's family has been serving the Austin community. Throughout the years, the Avila family has become a dynasty among East Austin businesses and has generated a loyal customer base. Generations of families have patronized and been employed by this family business from the beginning of La Oriental at 2305 East Ninth Street to Joe's Bakery & Coffee Shop at 2305 East Seventh Street. The story of Joe's Bakery & Coffee Shop is four generations in the making and shows the perseverance, commitment and loyalty of one family.

The family business began in 1935, when Joe's mother and stepfather, Sophia and Florentino de la O, opened La Oriental Grocery & Bakery at 2305 East Ninth Street. The bakery on Ninth Street was not just a place of business, but it was their home; they lived in back of La Oriental. The small neighborhood bakery was the hangout for adults and children to catch up on the local news and events in the community. Florentino, a talented baker, worked diligently to bring the traditional style of pan-Mexicano to the neighborhood. He was a hard worker who continued to work for numerous bakeries around Austin while maintaining his own bakery. For twenty-two years, La Oriental flourished on East Ninth Street until closing its doors in 1957.

Sophia and Florentino took some time off and, in 1961, rented a small space in a commercial building at 2223 East Seventh Street (today, the address is 2217 East Seventh Street). The building housed several small businesses, and with the small space, their bakery business was rebuilt. However, due to the ailing health of Florentino, Sophia sold the bakery to her eldest son, Joe Avila, in 1962. Joe, who had become Florentino's apprentice over the years, took on a partnership with his brother-in-law, Joe Hidrogo. The two men named the bakery Joe's Bakery & Coffee Shop, and their new business endeavor took off. While business was underway, the partnership did not endure, and after a few months, Joe Avila and his brother-in-law amicably parted ways, leaving Joe to run the bakery solo. By himself, Joe took on every aspect of running the bakery, working sixteen- to eighteen-hour days, and soon found himself with visions of expanding his bakery into a restaurant. Joe convinced the owner of the building to allow him to rent a larger space, enabling him to add a kitchen, countertop and dining room. During this time, Joe's wife, Paula, worked at H-E-B, but by 1965 she had joined Joe at the bakery. A young woman with little experience in the kitchen, Paula relied on the help of her mother-in-law, Sophia, and a family friend, Mrs. Torres, to help her find her way around the kitchen. Together, the women brought in old family recipes and created the taste of Joe's Bakery & Coffee Shop.

In 1969, Joe and Pauline took out a loan for $30,000 and relocated the restaurant two doors down, to the old Lott Lumberyard, at 2305 East Seventh Street. In 1980, Joe and Paula's youngest daughter, Carolina, joined her mother and father in the family business. For years Joe, Paula and Carolina worked together to bring the flavor of Joe's Bakery to its loyal customers. In 1998, due to health reasons, Joe officially retired from running the daily

operations of the business, and his eldest daughter, Rose Ann, stepped in. In 2001, Joe's Bakery & Coffee Shop was incorporated—a long journey from is beginnings in 1963. In January 2002, Rose Ann retired from her job of thirty years at State Farm Insurance to run the business full time. In 2003, Rose's daughter Regina joined the family at the restaurant to help carry on the family tradition. In 2011, Joe L. Avila, with his family beside him, passed away of lung cancer. It was a tremendous loss to the family and to the community.

Today, Rose Ann, Carolina and Regina manage the restaurant, continuing the legacy that began fifty years ago. Paula continues to take part in various aspects of the restaurant and can be seen peeking her head around Joe's Bakery, along with the newest members of the family, Izabella and Evalina.

What is your most popular breakfast taco and why? What makes it stand out?
Our most popular breakfast taco item is our bacon. People tend to think our bacon is deep-fried, but it's not. Our bacon is battered in an all-purpose flour before it is put on our grill. Once it is grilled, the bacon takes on a nice brown color and crispy taste.

Why do you think Austinites love breakfast tacos so much?
The breakfast taco is a staple in Austin because there are so many variations to choose from. Originally, the taco was for the working-class person who couldn't afford to buy their lunch, and their wife or mother would make them breakfast and send a taco: a hot one for the morning and cold one for lunch. However, over the years, the taco has gained popularity because of the smaller portion sizes and the ability to create your own taco. The taco allows people the freedom to pick and choose their favorite items and create the best combination for their taste buds.

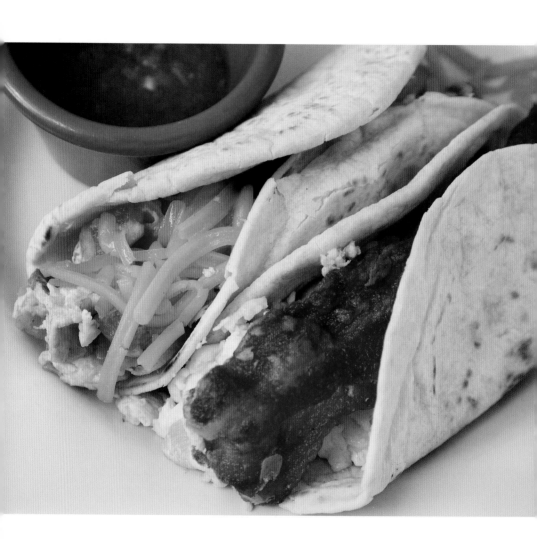

Bacon and Egg Taco

1 tortilla of your choice (Of course, we prefer flour because they are made fresh daily.)
1 teaspoon oil in frying pan (We use melted shortening, just the way grandma used to. For the health conscious, you can use olive oil.)
1 egg, scrambled well with salt and pepper
1 bacon (Our famous bacon is coated in an all-purpose flour before it is placed on the grill.)

Add bacon and egg to hot tortilla and fold.

Miga Con Todo Taco

1 teaspoon oil in frying pan
¾ ounce onions
¾ ounce tomatoes
¾ ounce green jalapeño peppers
½ handful of corn tortilla chips
1 egg
1 tortilla of your choice
¾ ounce shredded cheddar cheese

Cook onions, tomatoes, green jalapeño peppers and corn chips in the oiled frying pan for 1 minute. Add egg, mixing and cooking well with the veggies and corn chips. Add migas to hot tortilla, add cheese and fold.

Tell us your story.

My name is Juan Meza. I grew up in Laredo, Texas, in a big family. We're first generation here. I saw my parents work really hard; they would pick lechugas or melons, whatever was in season. My parents really pushed us to get a good education because they knew that was the way to make a better life. All of us in our family have our degrees. You see generations of families in Mexico that never move forward, and when they don't advocate and push for an education for the young kids, they stay stuck right where they are. When kids start behind in school, it's hard to catch up. And you have kids that move all the time with no stability at home, and it makes it hard for them to stay on track at school. I became a teacher, and at the time they were recruiting bilingual teachers here in Austin, so I came up here. I was twenty-three years old with a new job. I bought myself a new car with that new car smell, but teachers don't make a lot of money. I was paid about $800 a month. Once I paid my car, the rent and bills, there wasn't a lot of money left over. So I took on another job washing dishes. And you know, I liked being in that restaurant! I liked the people coming and

going. I liked all the noise. And it turned out they were selling this restaurant right here. So thirty-nine years later, we're still in the taco business.

My mom would make us tacos to take to school, and all the other kids would eat their sandwiches. We were too poor to buy sandwiches. No one would have ever told me you could make millions selling tacos. Who would have imagined?

What is your most popular breakfast taco and why? What makes it stand out?
Our Don Juan taco is pretty famous. It's a really big taco for not a lot of money, and we get a lot of orders for it. We serve it with fresh, warm tortillas. We make it with a lot of eggs, cheese, potato and bacon. So many people come in thinking that they can eat two, and they can hardly eat one. We have a Wall of Fame for those that can beat the record, but it's a whole lotta taco!

Why do you think Austinites love breakfast tacos so much?
Tacos are easy! You can make anything into a taco, and you can make it how you want it. Chorizo, eggs, cheese. You're allergic to eggs? Make it bean and papas, whatever you want.

I remember my mom would make breakfast—tortillas, papas and whatever else. And at the end of the day, whatever they didn't finish, we would eat the leftovers, and they were still good. You could put leftovers in another tortilla, and it was still delicious! So you can make a taco out of anything.

And they're fast, easy to eat on the go if you're in a hurry. But you can sit and stay a while, too. And cheap. We get a long line of university students here.

Don Juan Taco "El Taco Grande"

4 medium potatoes, boiled, peeled and diced
2–3 tablespoons vegetable oil
Salt, pepper and paprika, to taste
6 strips of thick-slab bacon, chopped into small pieces
1 extra-large egg
2–4 cooked flour tortillas
1–2 ounces shredded American cheese (Land of Lakes Extra Melt), for garnish
Serve with Juan in a Million® Hot Sauce

About 15–20 minutes before serving, pre-heat comal (griddle) for tortillas at medium heat. Scrub potato; peel, dice and boil until soft; careful not to overboil. Drain immediately and let cool.

In a 10-inch skillet over high heat, add vegetable oil. When oil is hot, place potatoes in skillet, stir occasionally and then add salt, pepper and paprika. Mix well and continue to stir until all spices are spread out as evenly as possible. Drain oil.

In a separate 10-inch skillet, cook the chopped bacon over medium-high heat until crispy. Then drain most of the bacon drippings, leaving a little behind, to continue cooking the remaining ingredients. While bacon is cooking, place the eggs in a bowl, beat with a whisk and set aside.

When bacon is completely cooked, and still over medium heat, add the diced potatoes and mix.

After all ingredients are mixed well, pour eggs over the rest of the potato and bacon mixture. Still over medium heat, when egg mixture begins to set, with a cooking spoon (or spatula), stir cooked portions slightly so thin, uncooked part flows to bottom. Avoid constant stirring. Cook until eggs are slightly set and all ingredients are well mixed, about 3 to 5 minutes.

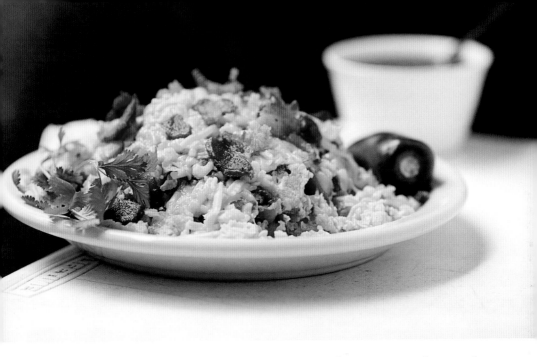

Heat tortillas on the comal (griddle) by turning them over every few seconds. Tortillas are ready when they have puffed up on each side. Flour tortillas are to be served soft with some golden spots, so be careful not to burn or toast them.

When tortillas are ready, place a tortilla on a plate (or taco basket) and add a large heaping spoonful of the egg mixture over the middle of the tortilla; fold the tortilla over, garnish with the shredded American cheese and serve with Juan in a Million® Hot Sauce and enjoy! Serves 2.

Tell us your story.

La Mexicana Bakery has been around since 1989, originally opened first as only a bakery. Due to such high demand, it became a taqueria/bakery over the years and even stays open all day and all night. It's a second home to me here, even to our Austin mates.

What is your most popular breakfast taco and why? What makes it stand out?

I would have to say our migas taco wrapped in our homemade tortillas. I think because the toasted tortilla chips give it a scrumptious texture and flavor.

Why do you think Austinites love breakfast tacos so much?

La Mexicana is a part of Austin. It seems like we are always being craved at all hours of the night. Sweet tooth satisfied!

BREAKFAST TACO RECIPE

Beef cheek marinated in our garlic/salt seasoning and than slowly steamed for six hours—and you have delicious tender barbacoa! Wrap it up in our homemade flour tortllas and top it off with some cilantro, onion and lime.

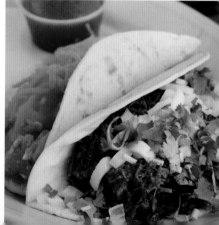

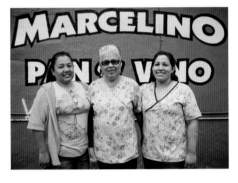

Tell us your story.

My name is Maria Vargas, and I own Marcelino with my daughter Raquel. I married my husband in 1968, and he lived in Minnesota, so when we got married we went there. I'm originally from Mexico, San Miguel de Allende. We worked for nine years in Minnesota, but he's originally from Texas, and we decided it would be good for our two girls to live in Texas and learn Spanish. I originally worked for a company that made medical parts, but I wanted to be independent and begin my own business.

We've been open for about twenty-four years, originally opened as a storefront called Abarrotes (Groceries). We began as a grocery store for about three or four years but saw that not a lot of money came in. We had a lot of business for some time because we had pressed ham and cheese sandwiches. But the brand of the ham changed, and then people didn't like them anymore. I had a neighbor, Mr. Mosqueda, and we had a volunteer group that made breakfast tacos for the church across the street. He suggested that I begin selling them, and I did. We continue the same tradition of what we did at the church. The restaurant is small, but it seems homey to people, and they like it.

The name changed because one of my grandsons, Marcelino, would always ask me to put his name on the store. We had to change the name at one point, and then my daughter said to add "pan y vino" after the Spanish movie. Marcelino is ten now, and we are training him to follow in his mother's footsteps.

We try not to put too much grease, use fresh and natural products and keep striving to make tacos that are even healthier and vegetarian because many people are looking for that. We need to do what is good for everyone, and you can do it, like tacos with nopales. I encourage my daughter, Raquelita, to continue learning. I tell her to seguir adelante and to learn new things that she can offer people as they change.

What is your most popular breakfast taco and why? What makes it stand out?
The most popular breakfast taco is the Papa Ranchera, egg and bacon. The potato is cooked in a special sauce with jalapeño, onion and tomato. It's a recipe that my daughter Raquel created. What makes the tacos special is that we let people design their taco, like choosing how much beans they want, so it's catered to their own taste.

Why do you think Austinites love breakfast tacos so much?
At first, breakfast tacos were not very popular because people didn't know. There were only two taquerias in the neighborhood at the time—Dos Hermanos and us. Breakfast tacos have become popular because people realized it's easy; when they are in a hurry, it's convenient to just grab a taco and go.

CARNE GUISADA

Our carne guisada, it's a special trim, so what we do is cut them up in cubes and then we put them in a pot to simmer with a little bit of water; once it's tender, we get our dry ingredients. A little bit of flour, a little bit of cornstarch, onion, garlic powder, cumin, salt and pepper to taste. You make a gravy, add cold water; you mix it up, and once the meat is stewed, it's very tender, and you add the gravy into the carne guisada. You let it simmer until it brings up to a gravy, and once it's a gravy, you have your carne guisada.

PUERCO EN CHILE VERDE

Pork butt cut in cubes. We deep-fry it to make carnitas. Once they are deep fried into a hard consistency, we drain the grease, and in another pot we boil onions, garlic, chile, jalapeños, tomatoes. They are tender to touch. You do them in the blender, and then you just generally mix the sauce into the pork. Then salt and pepper to taste, and there is your chile verde.

MARIA CORBALAN, MARIA'S TACO XPRESS

Tell us your story.

A native of Argentina, I left when I was sixteen, traveled around the world and decided to settle down here in Austin thirty-five years ago. After many jobs and trying to be an entrepreneur, I decided to open Taco Xpress. Taco Xpress started in 1997 in a small little trailer, and I was the only employee. After three months of having no success, I got a reporter from the Austin American-Statesman who wrote a great review, and the sales went up immediately. After that, I jumped to a whopping five-table restaurant. Twelve years later, after many more wonderful reviews, here we are. We are lucky to be well known and appreciated by so many.

What is your most popular breakfast taco and why? What makes it stand out?

My most popular breakfast taco is the migas taco. It's special because it's made with fresh ingredients and love, not to mention it's a favorite of Rachael Ray and Guy Fieri.

Why do you think Austinites love breakfast tacos so much?

Breakfast tacos are not only delicious but also symbolic of Austin culture. We have a lot of flavors in our city, and breakfast tacos are a tasty representation of the diversity in Austin. Tacos are very trendy and unique here, and I love the fusion tacos that blend different tastes and cultural backgrounds. Taco Xpress is just happy to be a part of the taco madness!

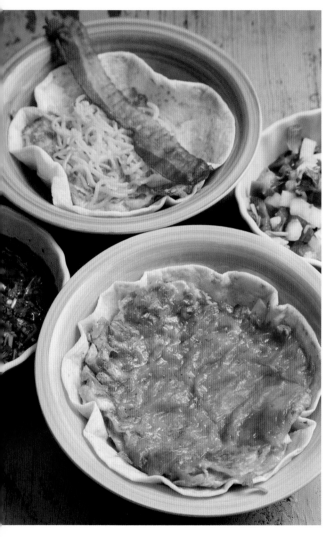

Migas Taco

Put a little bit of oil and a handful of crunched chips in the griddle. Mix together the pico de gallo and an egg in a bowl. Put the mix on top of the chips until it's cooked to perfection. Add cheese, and when the cheese is melted, transfer to one of our delicious homemade tortillas.

Tell us your story.

I am from the Valley; I didn't know I was from the States. I lived my younger years in Mexico City, in Saltillo. When I was fourteen years old, my mom said, "You were born in the Valley, in the United States." So I decided to come to the States, and my goal was to learn about business. I went to Del Mar College in Corpus Christi. My first experience with big-time cooking was with Amigos del Valle, a federal program to feed about two thousand elderly. Then I opened my first restaurant in the Valley, right by the Motel 6. I didn't find

it challenging enough, so I applied for a job in Austin. I fell in love with Austin with all the trees. I love the trees.

I worked at Chuy's as a manager and started running the whole thing and said, "What am I doing working for somebody else, not working for me?" In the meantime, I was a customer buying tacos, here and there, and found the tacos were not the kind of tacos I was used to, and I knew I could do better. In Saltillo, we call tacos palomas, the breakfast tacos, because the tortillas are white. That was only for breakfast tacos. I was originally curious and wanted to be the best in the area of breakfast taco because there wasn't very good-quality tacos at that time. There were very few options around, but I wanted to show people the difference.

I opened my first restaurant on MLK and Lavaca called Las Cajuelas, but it was a small place. I wanted to serve everybody; my attitude was always to take care of the customer. So I came in and found my current place on Manor, which I took over for

$500. I took the restaurant over on Friday, opened on Monday. My first customers walked in the doors and were like, "Who are you?" But when they tried my food, they said, "These are good!" and business spread like wildfire.

I love food because I helped my mom cook. When I was eight years old, I was making the corn tortillas on the press and all that...We didn't have a lot, but we had plenty of potatoes, plenty of beans, and made the tortillas. I put the corn to cook with the lemon at night and in the morning would grind it to make the masa. So I did the whole process, I loved to cook, BUT I never cooked an egg!

As you can imagine, making over-easy eggs—that was challenging! I learned how to do it, but it was hard for me. At the beginning, it was just me, my wife and one helper. And I was the cook. I opened in 1990 and started building it up. I did a lot of research on tortillas, looking in Houston, San Antonio and Dallas until I found the right one, and I am still sticking with them. I'm still with the same butcher; it has to be the best. Because of the relationship I have with the purveyor, they give me the best product. I still buy the produce from the same local people; they take care of me also.

I don't season the potatoes because I want you to season it yourself with my sauce. The sauce is very fresh—we make it every day. My whole thing, and the whole attitude in Mexico, is that you have to have the best hot sauce, for people to come just for the hot sauce, and that's what I created here.

The name was already here at the restaurant when I bought it. I thought it was such a beautiful name, and I decided to keep it. My mother was still supporting me after so many years, and that's why I kept the name. After having so much deprivation in my life, the American dream, it came true.

What is your most popular breakfast taco and why? What makes it stand out?
Migas for the vegetarians: fresh jalapeños, tomatoes and onions. Mixed with eggs. I buy the raw tortilla and fry myself. Everything for me has to be fresh, cook it right when you come in so it's fresh. Top it off with top-of-the-line cheddar with Monterey jack cheese.

Zero Taco: fresh potato, fresh egg (we break our own eggs), smoked bacon and cheese. I pay a high price for my bacon, and I show the whole strip rather than chop it up, and people love that apple-smoked bacon.

Our marketing is the taco—when you bite the first bite and you say, "This is so good!" And that's what I developed: quality, consistency in what you do is key. Everything that I have done, I did it from scratch; homemade is the way to go, and that makes a difference.

Why do you think Austinites love breakfast tacos so much?
I've been in Austin since 1986. The breakfast tacos were not always popular. It was a food we'd hide and eat ourselves because it was the cheapest food, because people were eating sandwiches. The perception was that sandwiches were high class and tacos were cheap. I began telling people that the taco is the way to go. Why? Because it's very portable, you can eat it while you're driving; I can make tacos of sushi if you want! Anything can be placed in a taco.

In 1996, I won the best taco in Austin according to the Austin Chronicle. Awareness grew then; people began to see that it was ok to eat a taco. Now, the taco is diversified in so many ways that I am like, "YES! YES for Austin!"

MI MADRE'S MACHACADO TACO

In the beginning, we used to buy our machacado (shredded dry beef) from Monterrey because that is the most traditional place to get machacado. One of the reasons it is most famous in Monterrey is because it is the desert region of Mexico, and not too long ago we didn't have refrigeration in those days, so people started preparing the meat and drying the meat to process it—dry it and salt it to process it and preserve the meat. After they dried the beef, they had to shred it, and they created machinery to shred the meat into machacado.

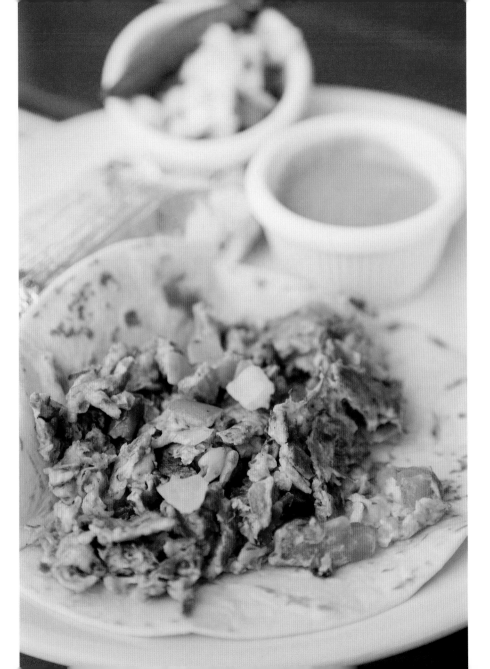

Now there's a lot of processing, and the quality of the meat is suspect. There are people that say they might be processing donkey meat, and it might be true! How are you going to know? So that's when I started to think, well, I should make my own machacado. I know how to do it, I just have to remember the whole process. So the way I do it is I buy the brisket, which is the cheapest cut, and we bake the brisket and then we shred it after that. After we shred it, we let it rest in refrigeration for about a week. And it did the trick for us because it would dry it even more. And it kept it safe. After that, we throw it on the griddle and we season it. We started putting black pepper, a little bit of cayenne. Even flavored machacado. You can put lemon in it or fajita spices. Up to this point, you can tell it's really a lot of work, shredding it, pull out the gristle. Then, after we cook it on the griddle, we use a little bit of oil, but not too much. We let it roast a little bit. Then we put it in a food processor, and that's how we shred it, with the spices and everything. It's ready to be used. We pack it and refrigerate it. When I make the machacado myself, I accomplish three things: quality control, preserves the flavors and ensures the safety of my customers, which is of ultimate importance to me. I don't even know if there is anyone else doing this, making their own machacado. It's really a lot of hard work. And I learned how to make the machacado because every day my mom would send me to get a block of ice because we didn't have freezers. And we would get the meat and cut up the steaks and have to process and dry it out right away.

Recipe

⅔ ounce machacado, heated on
 the griddle with bit of oil
Pico de gallo
Eggs, scrambled
Tortilla, heated

Let the machado and pico de gallo mixture cook a bit before adding scrambled eggs at the end. Serve on top of a hot tortilla, fold and eat.

Tell us your story.

I am from a small town in Mexico–Tejupilco–that's on an old road to Acapulco between the mountains. Tejupilco is an indigenous word that means "big toe"; in my hometown, there was a colony of descendants of the Aztecs. My town is a point of commerce for various states. I came here like any young person, with dreams to study and go to college, and fortunately I ended up in the restaurant business, which has worked for me. I was twenty years old when I came directly to Austin, and I don't plan on moving. I've loved it since I got here.

I went to Dallas to become a private pilot and left, then to college to study graphic design, and left, and I started working in restaurants. I think I brought it in my blood because my grandma in Mexico was a lady who had a taco stand, where they still use the wooden table with a gas lamp to illuminate it. My mom had two fondas of comida corrida, which means "home-cooked food." I think that's where it comes from, in my blood a little bit. I worked in engineering for about six years for Texas Instruments, Netscape and Cisco Systems, and I moved from the bottom up, but the economic crisis hit and I got laid off. I had some money saved and told my brother it was time to start a business, and we ventured with the restaurant Azul Tequila. Had one in Round Rock for some time and then we opened in Papalote.

When I was a child, I loved being out on the street, eating from the taco stands on the corners, things that are Mexican tradition that people carry on to this day, where in one place they sell sopes, in another they sell tacos, in another tortas throughout the town; where you go eat with the lady who became famous for her tacos. This

tradition still exists today. Everything I offer is original; I just adapted it to the modern market.

I've been cooking since I was five; it's nothing new to me. So I created the concept and recipes and teach people to make it. That's how I have made it to this point: going to Mexico and growing up in Mexico. I always like to bring a more urban, more modern concept to the food without losing the Mexican tradition in what I make.

Azul Tequila was my first business. Papalote I opened on my daughter's birthday, August 30, 2010. We created the breakfast taco thinking of people who eat healthy, vegetarian, who like to eat a little bit of meat in the morning while staying healthy. That's why we created this menu where you choose what you want to put in your taco. When we opened, we were a little scared, hoping people would like our concept. We didn't do any advertising; it was all word of mouth, and that's how Papalote was formed.

What I make are tacos de la calle–"street tacos," which in English doesn't translate directly because street can mean "junk food." But in the pueblos (small towns), street tacos refer to the tacos made by the lady on the corner. Papalote tacos are popular because the ingredients are fresh; the tacos are made in front of the client. They can see what the cooks are doing, the quality, no frozen foods, all natural. What you see is what you eat; we are not in the back doing something else. In Mexico, we say a lot la mano (the hand) because the flavor is in the hands, the hands are what make the food. It's not the same that an American make you Huevos a la Mexicana than a Mexican make them. It's a different flavor; in Papalote, all the cooks are from Mexico, the lady who makes the interior food is from Veracruz, the food is authentic. Everyone who works there are from the ranch; they have el sabor del pueblo (the flavor of the people).

What is your most popular breakfast taco and why? What makes it stand out?
There isn't a single most popular taco because at Papalote, people make their own tacos. We don't prescribe a specific one; we make it according to what people want.

Why do you think Austinites love breakfast tacos so much?
The breakfast taco has become very important. In the mornings, the taco is the breakfast, whether you're someone who works at an office, a teacher, an engineer—everyone in the morning will get their coffee and stop by for a taco. It's the main breakfast ingredient for those with a fast-paced life. Instead of cooking at home, they can stop, buy a taco and eat it on the way or at the office. I think it's an essential part of the times we live in.

The breakfast taco has become what Tex-Mex used to be for the office lunch awhile ago. Where there were enchiladas for $4.99 so people could come eat in thirty minutes. Now, it's one hour, but before it was less. I think that's what is happening with the breakfast taco; in a different epoch and a different economy, people are willing to pay a little more for a good taco than before, when they wouldn't care eating anything for just ninety-nine cents. Now you get more ingredients, and healthier, for a little higher price.

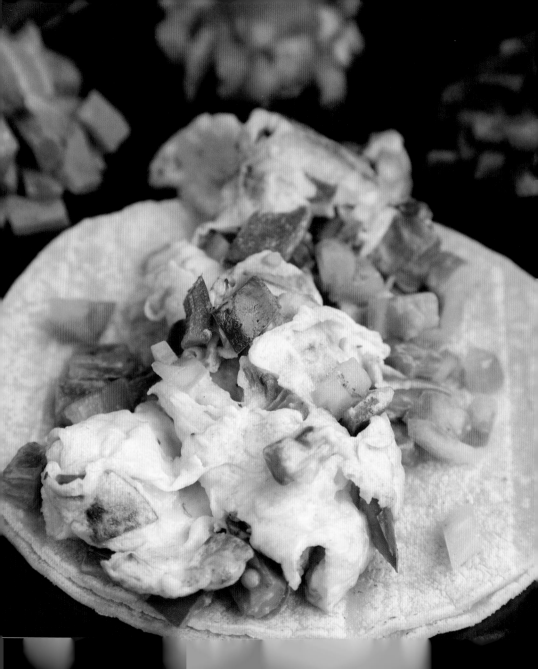

Eggs, Nopales, Mushroom and Tomato Taco

½ ounce of each of your favorite fresh vegetables (for this recipe, it includes nopales, mushrooms and tomatoes)
½ tablespoon vegetable oil
2 eggs
Corn tortilla

Before making the taco, boil the nopales in water with a little bit of salt for about three minutes. You can cut the nopales in small pieces or leave them whole. At Papalote, we like to cut them before cooking. Once the nopales are soft, place them under cool water and drain. Then, beat the 2 eggs and pour them on a hot griddle with oil. Add all the vegetables and mix with the eggs for about 30 to 45 seconds. Meanwhile, heat the corn tortilla on the griddle until it is soft and warm. Once ready, wrap the eggs in a taco.

Weenie con Huevo Taco (Weenie and Eggs)

1½ ounces of your favorite type of weenie (pork, beef, chicken or turkey)
2 eggs
1 tablespoon vegetable oil
1 flour tortilla
Optional: add your favorite type of cheese like mozzarella, provolone or queso fresco (Mexican cheese)
Salsa verde or homemade red sauce

Slice the weenie into ¼-inch slices. Beat 2 eggs in a bowl. Pour vegetable oil on a hot griddle. Cook the weenie and two eggs together, mixing them on the griddle for about 30 to 45 seconds. Meanwhile, heat the flour tortilla on the griddle until it is soft and warm. Once ready, wrap the eggs in the taco. Add your favorite type of cheese on top. Serve with some salsa verde or homemade red sauce, whichever you like best.

Tell us your story.

My name is Daniel Macias with Porfirio's Tacos. I was born and grew up in Austin. The restaurant was really started by my aunt and uncle, who opened the restaurant on February 9, 1985. I was about fourteen years old. I came into the picture around 1993; they didn't have any children of their own, so they raised me as their son. At first I couldn't speak Spanish to save my life, and I knew a lot of their clients or customers were Mexican, and the communication barrier was there. I didn't really want to work there, but when they couldn't find anyone, I gave it a shot. Back then, it was really interesting.

The restaurant is named after my grandfather–Porfirio Macias–who came from Monterrey, Mexico. When the restaurant opened, there weren't as many Mexican restaurants as there are today, and breakfast tacos weren't big. You could say that we were part of the few that were there and possibly the first in this neighborhood.

I took over the business in 2005, and the process has been a hard one. It takes a lot to run a business; a lot of people don't realize how much it really takes. They think you're making money hand over fist and you go home, jump into a bed full of money, but it's not like that at all. The neighborhood has changed a lot; old-timers have moved out, new people coming in. Now you have the little food trailers everywhere–everybody is doing it now. You feel it, so it's not as busy as it used to be, but we are still here because we've been here for so long. We don't do any advertising; it's all word of mouth. We were mentioned in the New York Times and Austin Monthly–that helps out a lot as well.

My motivation is that because I've been doing it for so long, just seeing the people come in. We are surrounded by schools, and I see these kids come in when they are little, and I see them grow up, and they are bringing their kids in. That gives me a drive to really come here for them.

For me, it's about the quality of the food. We still do things old-fashioned, labor-intensive; we still peel the potatoes and cut them by hand. We crack eggs and all that; other people tend to take shortcuts. But for us, it's about the quality and the fair price. What was important to me was that my aunt, she instilled in me that it's about quality, and the freshness of the product. So, that's what I would like to do, at least that we can be remembered for the quality even after twenty-eight years.

What is your most popular breakfast taco and why? What makes it stand out?
The breakfast tacos would be bacon and egg and potato, egg and bean. But a lot of people like our carne guisada taco, which is what we sell the most. I think it has to do with the quality, what we actually buy. We try to do everything fresh; we don't keep anything from the day before and serve it again. Everything is fresh that morning, and I think that's part of it.

We buy our tortillas, and a lot of people think they are homemade. I don't think the person would survive a week if they were making them back there. We actually buy them, but people really love them because they taste like they are homemade, and that's what I mean about quality—we have found the right ingredients and products so we can keep it going.

Why do you think Austinites love breakfast tacos so much?
Breakfast tacos were becoming more popular in the early 1990s because at that particular time the food trucks would go out. When I came into the picture, my aunt and uncle had thirteen trucks and three food trailers at the time, so it just boomed. After that, everyone started jumping on the bandwagon.

Carne Guisada

Cut stew meat into ¼-inch cubes. Add your favorite spices (Porfirio has its own secret family recipe). Simmer the meat in cooking oil. Add onions cut into little cubes to the meat and cook for about 1 hour. The onions will be reduced so much while cooking that you won't even feel them. Right before the meat is done, add flour and water to the meat and mix to make the gravy. Continue cooking until ready. Once the meat is ready, place in a flour tortilla.

Tell us your story.

I'm originally from Guanajuato, four hours north from Mexico City. What brought me here? Destiny. Many Mexicans come searching for better opportunities, and I am not the exception. I came when I was twenty-one years old and have lived here for about thirteen years. I like it a lot, so I decided to settle here. I came to live with my mother and father, who already lived here in Austin. I like everything about Austin—its cultural diversity, you find everything. I have Australian neighbors and others from Russia and from all over; everyone smiles, everyone treats you well. You can ask what you need, and they treat you well. When I didn't come here often, I

used to think it was a tough place to live in the east side, but having the food truck here, it's very accessible.

We ate breakfast tacos every day in Mexico. Many people I meet here say there are no breakfast tacos in Mexico, but I remember my mom and grandma waking up at four or five in the morning to grind the corn, make the tortillas. When we woke up, there were beans and eggs to make tacos. It was part of our essence, so I don't know who dares to say there are no breakfast tacos in Mexico! If you have tortillas, you have tacos! That's what I remember, tacos for breakfast and tacos for dinner.

My brother and I started the business. He has always been a cook, had always worked

in different restaurants in Austin and San Antonio. I worked as a server in different restaurants, too, so we decided to start something that was ours. We became business partners, wanting to do something different other than being employees and going from one job to another. My brother is no longer with the business; he decided to look for another type of work. Nestor is my other brother, whom I currently work with, and my sisters also participate—we are all one family.

When deciding on the name, my brother and I debated over who could come up with the most original. I had heard the name "Pueblo Viejo" and liked it because it brings to mind something "traditional," "authentic" from "pueblo" (a small town). It's in the small towns that you find good food, good people, good traditions—and if it's viejo (old) even better. That's where the name came from. I know a lot of businesses have that name in the United States and Mexico, so it's a catchy name for me.

The business was established three years ago. It's been different from what I expected. It's very difficult; you begin to attach yourself to what you're doing. Every day there's a challenge; sometimes you get tired from so much work, so much responsibility, but at the end of the day, you get the satisfaction of having something that's yours and how far you can go. Even if it's small, you feel independent. Our wish is to make Pueblo Viejo a sustainable source for our families in the future—that future generations in our family learn and come to love it and, if the possibility comes, to grow.

What is your most popular breakfast taco and why? What makes it stand out?
The most popular taco is El Taco Bueno with egg, chorizo, potato and cheese. It's very yummy; I like it a lot. Eduardo and I created the Taco Bueno. When we were making the menu, we had breakfast in mind. But for tacos, if you give customers the option to each choose their own, they can be unsure of what to get. So we decided to make our own combinations of what we like and give a name to a few, to make

BREAKFAST

TACO BUENO
Egg · chorizo · potato · cheese

TACO AZTECA
Ham · Egg · Jalapeño · beans

TACO VIEJO
Chorizo · Egg · potato · beans

TACO MI MADRE
Spinach · Jalapeño · mushrooms · Chee

TACO MARGARITA
Egg · mushrooms · spinach · onion

TICO TACO
potato · beans · Avocado

TACO DON CHAGO
Bacon · cheese · beans · Avocado

MAKE YOUR OWN TACO
CHOICES: Egg · beans · ham · sausage · bac
mushrooms · spinach · Jalapeño · chor
Tomato · onion · cilantro · zucchini · ch
AVOCADO ... ¢ 70

suggestions of what they can have instead of just making a list and you choose. It's something that has been very accepted by people.

What makes the Taco Bueno so good is the chorizo. The chorizo wakes up your appetite just smelling it. Another popular taco is the Taco Donchago. It doesn't bring eggs, but it brings bacon, which people like a lot. It has refried beans, cheese, bacon and avocado. It's also very yummy. We give the option of corn or flour tortilla. I like flour tortillas for breakfast because I feel it brings out the flavor of the eggs, beans, cheese, and it tastes better with coffee. I like corn with just meat.

Why do you think Austinites love breakfast tacos so much?

I've been in Austin almost thirteen years. We have customers from all over the world, and they come to try their first taco here. I can't imagine a world without tacos, but there is! I think being so close to Mexico, the border, is part of the reason. There are many Hispanics and Mexicans in Austin, and that has helped many people to accept the taco.

The tortilla is something that you can wrap anything in, like the dinner from last night, the eggs in the morning instead of bread; whatever it is, you can make a taco of many things, and that's your breakfast.

TACO DON CHAGO

Cook the pinto beans in water. Once they are soft, remove from the water. Golden some onions on a hot griddle with a few drops of vegetable oil and remove the onions so that only the oil will have the flavor. Add the cooked pinto beans and smash them until ready. Fry one slice of bacon per taco. Heat the tortilla (flour or corn). While the tortilla is heating, add cheese to melt. Add refried beans to the tortilla, then the bacon and, at the end, three slices of avocado. Add salsa verde or roja to taste.

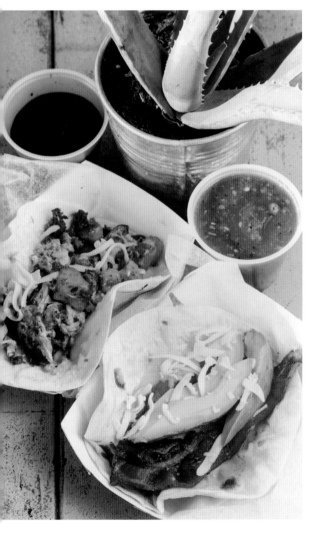

Taco Bueno
Makes 3 tacos

Cook 1 potato in water. Once it is soft, place it to grill on a flattop with some drops of vegetable oil. Add 3 ounces of Mexican chorizo. Mix and fry for about 1 minute. Add 3 eggs and mix until cooked.

Heat up the tortillas (corn or flour). When the tortilla is heating, turn it over and add Monterey jack in each tortilla. Add the egg and chorizo mix. Serve warm and ready to eat. Add salsa verde or roja to taste.

Tacodeli was started in 1999 by Roberto Espinosa, who had recently returned to Austin after a stint in the wine/alcohol distribution business in Atlanta. He quickly recognized the lack of quality Mexican food that went beyond the "dime a dozen" Tex-Mex-style tacos that were prevalent at the time and saw an opportunity. Inspired by the memories of great food from his childhood in Mexico City, he rented a small restaurant space on Spyglass by the greenbelt, and Tacodeli was born.

Shortly thereafter, Eric Wilkerson returned to Austin after a consulting stint in the corporate world. His friends had told him about a new restaurant with delicious food. He came into Tacodeli and immediately recognized the quality of offerings Roberto was producing. He came in frequently enough that the two became friends. Eric offered his services to help out the fledgling business by organizing the back-of-house affairs, allowing Roberto to focus on the cooking.

As they built up the business the next few years, they also developed core philosophies that they still carry on today and hope you will embrace as well:

We care about our food.

We constantly challenge ourselves to make the best tacos in town. We are the only taqueria in Austin with over forty specialty tacos. We produce everything in house daily with chef-driven recipes using fresh ingredients. Nothing goes on our menu unless we think it is excellent. We are proud of our food and are constantly looking for ways to make it better. We also care where the food comes from and try to source the best possible ingredients from as many local/organic sources as possible.

We care about our customers.

Without our guests we would not be a successful business. They have chosen to come to Tacodeli and spend their money with us. We appreciate this and truly care about the satisfaction of every customer that comes in the door. Our goal is to instill our guests with a desire to return and become regular customers.

We care about our staff.

Without our employees, we would not be a successful business. We have always thought of Tacodeli as a family. With over ninety employees, we have become a much larger family than ever imagined. That does not change the fact that we truly appreciate the efforts of our employees and care about everyone's well-being.

We care about Austin.

We love this city and make strong efforts to give back to the community. We make donations to Save Our Springs, Austin Pets Alive, MS 150, Lance Armstrong Foundation, Zilker Relays and various other schools, churches and organizations throughout the city. We also support local businesses by sourcing what we can from them. We have developed strong relationships with local outfits like Goodflow Honey, Farm to Table produce, Sarah Belle's Bakery, Quality Seafood, Cawoods Produce and many others.

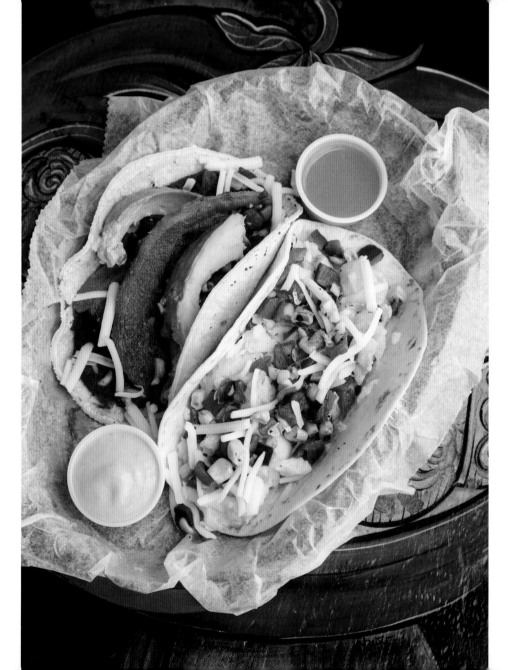

What is your most popular breakfast taco and why? What makes it stand out?
Our most popular breakfast taco is the Otto; it's our interpretation of a very classic combination of ingredients and flavor. We source all local and organic produce, and that really shows in the freshness and quality of the taco. It stands out in every bite.

Why do you think Austinites love breakfast tacos so much?
Once you've tasted a breakfast taco, you never go back! Breakfast tacos have become a way of life in Austin; we've been serving them for thirteen years. It's become a topic of debate amongst the locals. Everyone has their favorite spot for breakfast tacos, and people will stand behind their choice. Ultimately, an Austin morning isn't complete without a melt-in-your-mouth breakfast taco. We really value our customers, and it's our pleasure to help them get their breakfast taco fix.

THE JESS SPECIAL

Scrambled farm-fresh eggs
Onions, tomatoes and jalapeños, diced
Leftover tostada chips, crumbled
Monterey jack cheese, shredded
Avocado, sliced

Cook eggs until they set and scramble in following ingredients. Top with shredded Monterey jack cheese and avocado slices.

THE VAQUERO

Scrambled farm-fresh eggs
Pimiento (red bell) and poblano peppers, roasted, peeled, deveined and diced
Corn, roasted and sliced off the cob
Monterey jack cheese

Cook eggs until they set and scramble in peppers and corn. Top with Monterey jack cheese.

José De Loera got his start in the food business over forty years ago in his hometown of Aguascalientes, Mexico. The oldest of Maria and Alberto De Loera's seven children, José started working as soon as he could walk. Don Alberto ran a carnitas cart in town, Doña Maria was at home hand-making tortillas and young José ran back and forth delivering fresh, warm tortillas for the carnitas tacos. Don Alberto continued his carnitas tradition when he arrived in Austin, moving from one location to the next selling carnitas from the back of a truck. José turned his father's talent into a business in 2001, when he opened El Tacorrido, an authentic Mexican taqueria, at Rundberg and North Lamar. A second El Tacorrido location followed in 2008 on Berkman Drive, and a third location opened on South First at Oltorf in 2011.

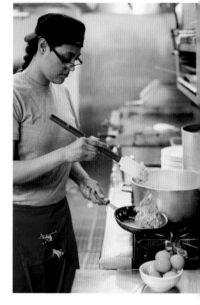

For many years, José wanted to expand on the idea of the taqueria business to create a place where he could share his mother's cooking, watch soccer with friends and showcase foreign films. He wanted an east side location that was accessible to anyone, where food was available late night and friends and neighbors could enjoy several times a week. After many years of work and a year of construction, the dream became

a reality when José opened Takoba on June 11, 2010, the first day of the 2010 World Cup

José's vision for Takoba is to provide consistently friendly and professional service in a unique and relaxing atmosphere and to create a comfortable, welcoming environment in which guests can enjoy consistently delicious food and drinks made from fresh ingredients and family recipes.

At Takoba, the goal is to build lasting relationships with guests and its neighborhood through repeat business and to build and maintain healthy financial status through hard work, dedication, honesty and integrity.

What is your most popular breakfast taco and why? What makes it stand out?
Our most popular breakfast is the potato, egg and chorizo. What makes this breakfast taco unique is that we make our chorizo in house and follow a recipe that has been in my mother's family for many years.

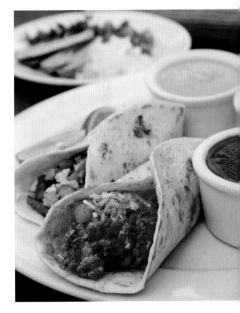

Why do you think Austinites love breakfast tacos so much?
I believe Austinites love breakfast tacos because they are a fast and satisfying replacement of a full meal that can be eaten on the go.

Taco Chorizo

Fresh flour or corn tortilla
Grilled onions and potato
Scrambled local organic Vital Farms eggs
House-made family recipe chorizo

CARMEN VALERA, TAMALE HOUSE EAST

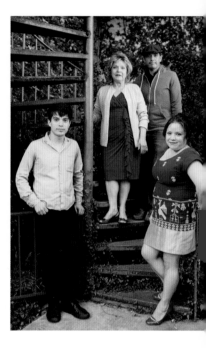

Tell us your story.

It all started in 1912, when our great-grandfather Antonio Villasana escaped the turmoil of the Mexican Revolution with his parents and siblings and settled in Austin, Texas. He was only thirteen years old at the time. By the 1920s, he had opened a small restaurant in what used to be a Mexican-American neighborhood located near present-day Austin City Hall. He called it Tony's Café.

By 1935, Antonio was the owner and operator of Tony's Tortillas in the Guadalupe Church neighborhood of East Austin. He quickly established a second tortilla factory in Houston. Tony's Tortillas was one of the very first tortilla factories in the state of Texas. His products were distributed to supermarkets and restaurants across Texas and throughout the Southwest.

Combining the tried-and-true traditions of family values and hard work, all of our great-grandfather's children worked at Tony's Tortillas. His oldest child, Carmen, our grandmother, started working at a very early age alongside her mother.

Carmen made candies and tortillas. In 1961, our grandmother Carmen and her husband, Moses Vasquez, opened up the Original Tamale House at the corner of Cesar Chavez Street and Congress Avenue. This take-out business soon became a successful and iconic Austin staple. Rumor has it that President Lyndon Baines Johnson used to have Grandma's tamales flown to the White House. A fact is that he would send his limo driver to pick them up for him when

he was in town. They sold the restaurant in 1988, making history in Austin real estate and even making national news.

Then, in 1977, Carmen's oldest child, our uncle Robert Vasquez, opened the Tamale House #3 on Airport Boulevard. His place was soon to become one of Austin's best-known Mexican food take-out restaurants with a nationwide reputation. He made the New York Times for being one of the first to sell breakfast tacos. A musician friend once said that the Tamale House has fed more musicians and starving artists (literally) in Austin than any other place.

Uncle Bobby has operated his business for thirty-five years and has been a mentor and supporter of the Tamale House East. He is also one of the last remaining veterans of the 1980s' infamous Austin Taco Wars. Without his support and help, the Tamale House East would not be possible. He is usually seen at Tamale House East on Sundays, providing advice and encouragement to us, his nieces and nephews. Throughout the years, other locations of the Tamale House have included one at the intersection of Guadalupe and Twenty-ninth Street operated by our Aunt Peggy and another one at College Avenue in South Austin, operated by our grandmother Carmen.

In 1982, our mother, Diane Vasquez-Valera, who had worked with her mom, Carmen, at the original Tamale House on Congress since the age of thirteen, opened her own place, México Típico Restaurant. After two years in Montopolis, she moved the restaurant to the current Tamale House East location at 1707 East Sixth Street. Our father, Juan Valera, who emigrated from Peru in 1963, designed and constructed the building that we currently occupy. In 1984, an apartment was added to the second floor of the restaurant, and that is where we grew up. So, yes, we can say we actually grew up in the restaurant business!

México Típico quickly developed its own following and was widely recognized as one of the fifty best Hispanic restaurants in the United States. It was at this location that our great-aunt Betty, Antonio's daughter, came to help our

mom. She not only helped operate the restaurant but also helped raise the five Valera children. After over forty years of working in the restaurant business while raising five children, our parents closed México Típico in 2000. Since that time, we have continued to make this place our family home.

During the years following México Típico's closing, our mom, Diane, and our aunt Cathy Vasquez-Revilla, who was a City of Austin planning commissioner and owner of La Prensa newspaper, decided to start a movement. They organized east side business owners and residents to develop the Plaza Saltillo Concept. Together, they convinced Capital Metro to donate land and secured federal funds for the plaza's construction. Plaza Saltillo is now not only a light rail stop but also a testament to the families who settled and preserved the rich cultural heritage of our beautiful east side community for everyone to enjoy.

Many of México Típico's customers tell us they remember it fondly. They like to tell us which booth they sat in and request that we bring their favorite dishes back. We are happy to oblige. Another generation remembers the famous tamales at the original Tamale House on Congress. Some were only children at the time and now return with their own children and grandchildren.

Now, as it often does, life has come full circle. There's still a Carmen, Roberto, Juan and Antonio (José) in the kitchen, but now we've added a Colombina. The scenery is a little different these days, but the family recipes and traditions remain the same. And yes, we serve breakfast tacos all day long.

We invite you to experience and savor not only fresh, delicious and homemade food, including the breakfast tacos that have been perfected over generations at the Tamale House and México Típico, but also to experience, in a century's worth of recipes, memories and traditions with your own family and friends. We hope to bring you new and exciting culinary dishes to enjoy, while continuing to preserve the rich cultural heritage and history of Austin's east side. It is our honor to serve you, as we continue what our great-grandfather started all those

years ago. Our casa is always your casa, too, and at the Tamale House East, we will always make you feel right at home.

What is your most popular breakfast taco and why? What makes it stand out?
The potato, bacon, egg and cheese is our most popular breakfast taco. We write it as the PEBKCHZ just as our grandmother did and our uncle still does. It is a simple taco but a tried-and-true one. It stands out because of its taste. The hickory-smoked bacon and grated cheddar cheese bring just the right amount of salt to the mix. It is a complete meal in and of itself. What makes it extra special is our grilled tomatillo salsa.

Why do you think Austin loves breakfast tacos so much?
I think the breakfast taco is just so embedded in the culture if Austin. I mean, our family has been making and selling them since at least 1961! They may have even been served in downtown Austin at Tony's Café in 1912. They have withstood the test of time. We sell breakfast tacos at four in the morning and eleven at night. Austin is such a creative place, and yes there are actual starving artists here. Breakfast tacos help sustain them, and in return, they feed our hearts and souls.

Breakfast Taco Recipe

Here is the recipe for our most popular taco, the potato, egg, bacon and cheese. Customers order this taco in all different ways, asking for the ingredients in all the possible ways four ingredients can be combined, but this is the way we always write it down.

6 *eggs*
1 *pat of butter (optional)*
½ *cup heavy whipping cream (optional)*
½ *pound cheddar cheese*
2 *medium potatoes*
Onion
½ *pound hickory-smoked bacon*
6 *tortillas*

In a mixing bowl, scramble 6 eggs with a hand mixer. You can add a pat of butter or ½ cup heavy whipping cream for super-rich eggs. You don't want to just crack the egg and scramble the eggs in the pan because then the white and the yolk will remain separate.

Take your cheddar cheese and grate it. Set aside.

Cube your potatoes and sprinkle them with salt and pepper.

Using ½ cup vegetable or canola oil, heat up your saucepan, getting the oil nice and hot before you cook your potatoes so they don't get soggy. Add a bit of onion for flavor and cook your potatoes. Strain the oil out and put your potatoes back in the pan. Lower your heat, and slowly cook your eggs for a classic potato and egg combination.

In a separate pan, fry your bacon. We like a nice hickory bacon. While we prefer a firm, not completely cripsy bacon, you can make yours to your preference. Strain your bacon and place on a plate with a paper towel to soak up the excess oil.

Warm your tortillas on either a comal, if you have one, or a cast-iron skillet to simulate a flattop grill.

Fill your tortilla with your potato and egg, add your bacon and sprinkle on your cheese. Eat your taco and enjoy! Makes 6 tacos.

Tell us your story.

My name is Manuel Lopez Galvan. We've been here for fifteen years. With a lot of hard work and sacrifice, we've been trying to give the best service possible. I used to work at Arrandas, where I learned a bit about the business. And then we decided to start our own business. My brother, his name is Alejo, we started as partners, and now he runs his own restaurant. We have one on Congress and one off Highway 71. I'm from Jalisco, Jesus Maria de Jalisco. It's a small pueblo. And most people there are taqueros. Everyone goes out to DF, Guadalajara, the United States to start up their taquerias. A lot of people here in Austin are from my town. Arrandas, Vallartas—we're all from the same place. Almost everybody in town is in the business of tacos, so we got into it, too.

What is your most popular breakfast taco and why? What makes it stand out?

The chorizo with eggs is very popular. The bacon and egg is also very popular. We get really good chorizo, and we cook the chorizo on the plancha so it fries up. You can't put the eggs in right away. First, let the chorizo fry up so it releases its flavor.

Why do you think Austinites love their breakfast tacos so much?

Well, I'm from Jalisco Guadalajara, and we eat menudo for breakfast and a strong meat taco for breakfast, not so much egg. There are hardly any places that make an egg taco in Jalisco.

I think these are food traditions that come from each place, and the people keep up their food traditions. For example, in Guadalajara, we eat menudo, and there's a barbacoa taco called taco dorado. It's made with a red meat estilo birria. You put it on a skillet, cover it and put it on a lightly fried tortilla. It's the most popular, traditional breakfast in Guadalajara. Anywhere you go in Guadalajara, you can get the taco dorado for breakfast.

BREAKFAST TACO RECIPE

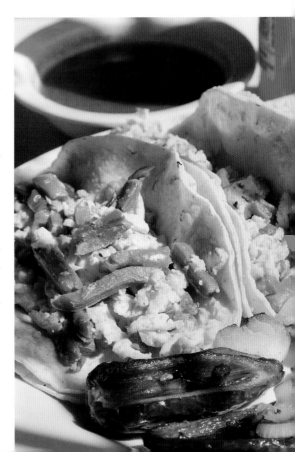

For me, the most fundamental part of preparing the breakfast, it's all about putting the ingredients in the right order. The eggs always go last, that way they absorb the flavors of the chorizo, the bacon, nopal or whatever else you're using. If you just throw it all together, the flavors don't get absorbed into the eggs.

In Jalisco, we do eat eggs and nopal. First, you chop up the nopal with oil, and once it's cooked you add the eggs. We make a salsa with chile, tomato, onion, and it's prepared separately. Once the nopal is ready and the eggs are scrambled well, you can add the salsa so it adds its flavor. And that's eggs and nopales!

Tell us your story.

I have been in the culinary industry for two and a half decades. I've been a busboy, a sous chef and everything in between. My executive chef career began at the age of twenty-one for the World Bank in Washington, D.C, and carried me to every coast to head some of the largest kitchens in the country—Disney, MTV Studios, Enron and, finally, Dell in Austin, Texas.

I'm an idea man, so when I had the opportunity to start my own business, I traded in everything I could to get me started on the Taco Dream of Torchy's Tacos. To start, we had a six-taco menu and a Vespa that served to get the word out. Over time, we grew a following and nearly grew out of our mobile unit. In addition to the trailer, Torchy's Tacos now operates a number of brick-and-mortar locations across Texas.

What is your most popular breakfast taco and why? What makes it stand out?

The Monk Special (eggs, bacon, green chilis and cheese) is a breakfast favorite. Individuals love it because it's legendary. The Monk was named after a loyal friend and part-time security guard who helped monitor the original Torchy's trailer after hours.

Why do you think Austinites love breakfast tacos so much?

The tortilla is a powerful thing. Potatoes, eggs and bacon are good, but put it in a portable wrap that can be carried to the park with build-your-own mimosas? C'mon— that has Austin written all over it.

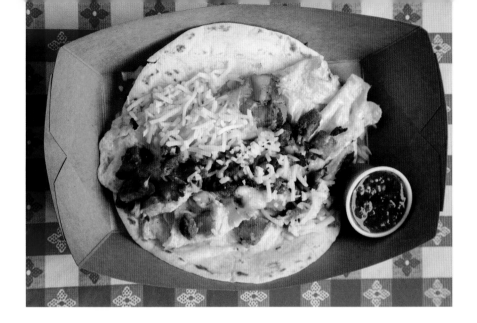

THE WRANGLER (EGGS, POTATOES, BEEF BRISKET AND JACK CHEESE, SERVED WITH TOMATILLO SAUCE)

1¼ ounces breakfast potatoes, seasoned to taste

3 ounces eggs, whipped (approximately 2 eggs)

1½ ounces beef brisket, smoked and chopped

1 flour tortilla

1 ounce jack cheese, shredded

1 ounce your favorite salsa

Sautée seasoned breakfast potatoes with margarine until warm throughout. Cook until slightly soft and then pour whipped eggs on top of potatoes. While egg is cooking, cook brisket on medium heat until cooked through. Flip egg and potato mixture.

Once egg is prepared, layer tortilla with potato and egg mixture, cooked brisket and jack cheese. Serve with side of your favorite salsa (preferably Torchy's Tomatillo Sauce).

Tell us your story.

We are from Veracruz, Mexico, and have two trailers called Veracruz All Natural and have been living in Austin for thirteen years

We started working at restaurants, starting as servers at first. We always loved cooking. My mom loves to cook; she's the one that will make you recipes and all that. So we began to cook, eventually formulating a plan to start a business until we thought, "Well, let's do it!" So we became business partners.

We started selling raspas (ice cones) in a small truck. Then I got the idea to add fruit and natural juices and smoothies. Eventually, the customers started asking me for food. They wanted something to eat. Since we like to cook anyways, we started adding breakfast tacos, tortas and all that. That's how it began.

We had the idea of having something healthy at the beginning because we came from selling juices and fruits—the name came from there. We had the idea to sell only natural foods, but then my mom gave us the idea of adding meat tacos, and that's how we started. My mom helped us choose what meat tacos to sell, and we would add the vegetarian and started our recipe—Taco La Reyna—which includes vegetables and eggs; it's like an omelet. That migas, you can find anywhere, but each person has their own style, so we created our own. We always liked the idea of having handmade tortillas, and our sauces, they are our recipes. Always, since we started selling tacos three years ago, we have made the tortillas by ourselves.

We don't reheat them; we cook them when the customers order them. That's the difference from many places—here they come out soft.

One of the important things to know about owning a restaurant is that you have to sacrifice things and be consistent because sometimes things will not go the way you want them, but you have to keep the faith because for a long time we worked without a salary. For the first two or three years, we didn't profit; on the contrary, it was all investing, and people would tell us to give up because it was too much work.

We would practically work from 7:00 a.m. to 9:00 p.m., and all we earned was to invest, and we wouldn't make money but to pay rent and eat. But we were committed to the idea that one day we would do well, and not work for someone, because that was our goal, and today we have achieved it. We don't have to work for anyone; we are just dedicated to our two locations. Having a business is not easy, but if you love your business like we do, not only for making money but because we like it—we like being our own bosses and meeting new people, and most of all, we love what we do. That's an important point.

We feel good when people say, "It's very yummy" or "It's great that you're here." Or they come specifically to see it. It feels good to be recognized for your work.

It's that moment when people tell you, "This is the best I have eaten in Austin" that's our pay for our sacrifice or the hard times that you go through when starting a business. Another important thing is that we are business partners; we are sisters, but behind us are our parents who have always supported us. My mom and dad are always helping us. Family unity is very important when you want to start something. They have always supported us and advised us, and that has been important.

What is your most popular breakfast taco and why? What makes it stand out?
The most popular is the migas taco. It's the most popular because it's really good!

The taco is tortilla chips with pico de gallo; we add avocado and cheese on top. The flavors, and the handmade tortilla—it's like no other place sells it like this. A lot

of restaurants may have migas, but the tortilla is made from a company. The tortilla chips we fry ourselves, so they stay crunchy, so when you mix it, it doesn't fall apart and stays crunchy.

The sauces are also very important. The most popular one is the molcajete that we make ourselves with tomato, jalapeño and cubes of avocado. People see the colors and the flavor; they like it a lot. They are not watery salsas, and so they can eat it on the road without dripping. People tell us what they like, and we learn from our customers and always try to get better.

Why do you think Austinites love breakfast tacos so much?
Here in Austin, I think people like the breakfast taco because there are a lot of vegetarians and vegans. I think vegetarians don't have many options in many places. I think the breakfast taco is one more option for vegetarians. What we sell the most is the migas taco, potato and cheese and the nopales and eggs. Eggs are more easily adapted to vegetarian meals.

The Migas Tacos

The migas tacos are very popular here at Veracruz All Natural. We make the tortillas (yes, they're handmade) and tostadas fresh to order. Many people use chips from a bag, but we use our own fresh tortillas. To make the tostadas, we tear them into strips and lightly cook them in oil before adding them to the eggs.

We really like the taste of fresh ingredients, so we use really fresh pico de gallo, cilantro and onion. We don't use jalapeños because some people may not eat spicy food. We add the eggs last, and it all cooks together. And it all goes on a fresh, warm tortilla.

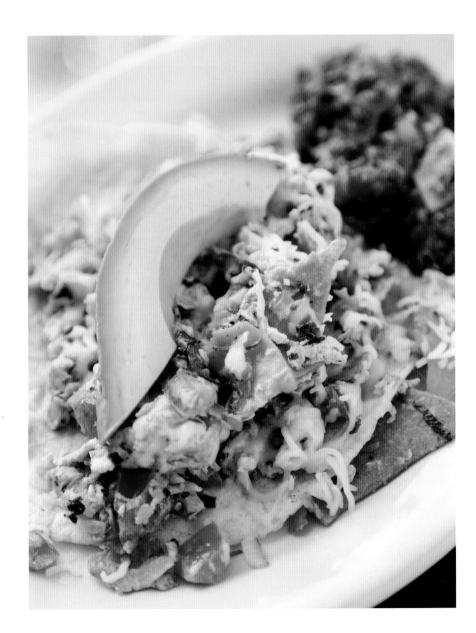

Tell us your story.

I have always loved to cook. My sisters and my parents have always loved to be in the kitchen trying different recipes. I had a chance to be part owner of a restaurant at age twenty-four but left the business due to my need for regular work.

I moved to Austin ten years ago and had the blessing of raising my son and seeing him every weekend. While we were in the kitchen preparing and mixing, he learned how to do small tasks. For many years, my son kept telling me that I should start making tacos around the area we live in. He was saying to me, "Dad, start selling your salsas and tacos!" When my son was in kindergarten, I brought tacos to him at school, and after two or three years, my son's friends started asking me if I could bring them tacos on Fridays. I enjoy seeing people's faces when they take their first bite and when they decide what salsa they like the most. I dedicate all this effort to my son and my future wife, whom I have not met yet, wherever she is.

What is your most popular breakfast taco and why? What makes it stand out?
Today, one of my most popular breakfast tacos is barbacoa and eggs. The combination with the four tortilla, chiles, salsas, spicy tomatillo or our ghost salsa makes a great breakfast taco.

Why do you think Austinites love breakfast tacos so much?
I think Austinites have lived for generations with the flavors of great breakfast tacos, and it's a great way to start a day.

Breakfast Taco Recipe
You can always find barbacoa in different stores, and the best way to mix the eggs with the barbacoa is making the eggs over easy and then finish cooking them with the barbacoa on top. When you're about to finish, you should have a warm tortilla ready and enjoy your barbacoa and egg taco.

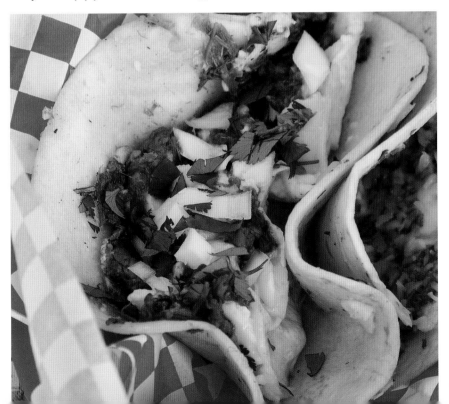

SOURCES

Austin History Center. "Chili Once Sold at Open Stands." February 28, 1957.

Austin Public Library. "Austin's 'Mexico': A Forgotten Downtown Neighborhood." October 9, 2012.

Burandt, Jaqueline Hammett. "Tex-Mex: A Capital Idea." APT Bulletin, n.d. Article found at Austin History Center.

Monroe, Karl. "The Mexican Population of Austin, Texas." BA thesis, University of Texas at Austin, 1925.

West, Richard. "From Mexico with Love." *Texas Monthly* (June 1977).

Whiteis, Andrea. "Tacos, Tamales and Traditions: The Role of Immigration in the Growth of Mexican Food Restaurants in Austin." BA thesis, University of Texas at Austin, August 2004.

Wright, Hamilton. "He Ate Tamales Back in 1893." *Austin American-Statesman*, November 11, 1963.

PHOTO CAPTIONS AND CREDITS

Page 15. *Illustration and Design by Rafael Picco, www.behance.net/rafaelpicco.*

Page 22. Minerva Lopez serving it up at Taqueria Chapala. *Photo by Dennis Burnett.*

Page 24. *Photo by Dennis Burnett.*

Page 27. The farewell gathering before the Tamale House on Congress closed down. *Photo by Juan Valera.*

Page 28. *Photo courtesy of Glenn Rosales.*

Page 30. *Photo by Dennis Burnett.*

Page 35. Mando's Mexican hands. *Photo by Joel Salcido.*

Page 38. *Las salsas de* Takoba. *Photo by Dennis Burnett.*

Page 41. Breakfast Taco Drawing. *Illustration by Pepe Yz, PepeYz.com.*

Page 45. *Austin American-Statesman* food writer *y bloguera* Addie Broyles and son, Avery Jack Knox-Broyles. *Photo by Joel Salcido.*

Page 47. My Morning Migas, with Brussels sprouts, by Addie Broyles. *Photo by Joel Salcido.*

Page 48, top. Austin pit master and *el hombre* behind Franklin Barbecue, Aaron Franklin. *Photo by Dennis Burnett.*

Page 48, bottom. Aaron Franklin's go-to breakfast taco: brisket with fresh avocado slices and salsa. *Photo by Dennis Burnett.*

Page 49. Granddaughter of Lady Bird and President Lyndon B. Johnson and Austin native Catherine Robb. *Photo by Dennis Burnett.*

Page 51. Catherine Robb's bacon, egg and cheese breakfast taco, served on a plate from the LBJ Ranch. *Photo by Dennis Burnett.*

Page 52. Los Creatives, Celeste and Adrian Quesada (Austin Film Society/ Grupo Fantasma), with mariachis in hand. *Photo by Joel Salcido.*

Page 53. The Quesadas' mariachis, aka breakfast tacos: bean, potato, egg and cheese breakfast taco. *Photo by Joel Salcido.*

Page 55, left. David and Joe's muy grande breakfast tacos: eggs, beans, potatoes, bacon, avocado, tomatoes and cilantro. *Photo by Joel Salcido.*

Page 55, right. David Alan and Joe Eifler, master mixologists and Austinites, behind Tipsy Texan. *Photo by Joel Salcido.*

Page 56. Austin's Soup Peddler, David Ansel, with his daughter Mia. *Photo by Joel Salcido.*

Page 57. Soupy's bacon, egg and cheese breakfast taco, topped with homemade red and green salsas. *Photo by Joel Salcido.*

Page 59. Dorsey Barger and Susan Hausmann, urban farm entrepreneurs and owners of HausBar Farms. *Photo by Joel Salcido.*

Page 60. HausBar Farms' Duck Egg and Nopalitos Tacos. *Photo by Joel Salcido.*

Page 63. George Milton, the man behind YellowBird Sauce, Austin's all-natural habanero condiment. *Photo by Dennis Burnett.*

Page 65. Hoover Alexander, native Austinite, fifth-generation Texan and owner of Hoover's Cooking in East Austin. *Photo by Dennis Burnett.*

Page 66. Hoover's Elgin sausage, cheese and egg breakfast tacos, served inside flour tortillas with cheddar cheese, home-fried potatoes and onions. *Photo by Dennis Burnett.*

Page 68. Jodi Bart Holzband and Adam Holzband, curators of Austin food blog Tasty Touring. *Photo by Joel Salcido.*

Page 70. Adam's Fried Egg Taco with Avocado, Chipotle Sauce and Black Beans. *Photo by Joel Salcido.*

Page 73, left. John's Hawaiian twist on the breakfast taco: eggs, shrimp, spam and cilantro. *Photo by Joel Salcido.*

Page 73, right. John Conley, owner of Conley Sports, keeping Austinites fit with the Austin Marathon and Cap10K. *Photo by Joel Salcido.*

Page 74. José Velásquez, East Austin activist and founder and president of Hermanos de East Austin. *Photo by Joel Salcido.*

Page 75. José Velásquez's Serrano, egg and cheese breakfast tacos. *Photo by Joel Salcido.*

Page 77. Breakfast taco memories: Juan Castillo Jr., Kathy Vale and Juan Castillo Sr. *Photo by Dennis Burnett.*

Page 79. Homage to the breakfast taco: bean and egg with bacon. *Photo by Dennis Burnett.*

Page 81. East Austin roots with *familia* Limon: Lonnie Limon, Crystal Cantu, Diana Estrada and Virgil Ojeda Limon. *Photo by Joel Salcido.*

Page 83. Limon family carne guisada tacos. *Photo by Joel Salcido.*

Page 84. Austin City Council member Mike Martinez. *Photo by Dennis Burnett.*

Page 85. Mike's abuelita-inspired breakfast tacos: eggs, avocado, poblanos and cojita cheese. *Photo by Dennis Burnett.*

Page 86. Austin's resident techie, Omar Gallaga, tech culture writer at the *Austin American-Statesman. Photo by Joel Salcido.*

Page 87. Omar G's tube sausage, egg and cheese breakfast tacos. *Photo by Joel Salcido.*

Page 88. Top Chef Paul Qui and Deana Saukam, Eastside King and Qui. *Photo by Dennis Burnett.*

Page 89. The Qui breakfast taco, with sprouts, farm eggs, potatoes and myriad other fresh ingredients. *Photo by Dennis Burnett.*

Page 90. Austin singer-songwriter-angel Sara Hickman. *Photo by Joel Salcido.*

Page 92. Tim and Karrie League, founders of the Alamo Drafthouse, at home in Austin with their children. *Photo by Dennis Burnett.*

Page 95. *Illustration and Design by Rafael Picco, www.behance.net/rafaelpicco.*

Page 97. Alton Jenkins, takin' care of business at Cenote. *Photo by Dennis Burnett.*

Page 99. Coffee shop tacos: bacon and egg from East Austin's Cenote. *Photo by Dennis Burnett.*

Page 100. Clovis and Diana at Cisco's Restaurant Bakery. *Photo by Dennis Burnett.*

Page 103. Cisco's famous migas taco. *Photo by Dennis Burnett.*

Page 104. Jorge Garcia, owner and operator of Curra's Grill, the "Mother of All Mex." *Photo by Dennis Burnett.*

Page 105. Curra's machacado and egg taco. *Photo by Dennis Burnett.*

Page 106. Jose Luis Perez doing what he does best at El Primo trailer. *Photo by Dennis Burnett.*

Page 108. Breakfast tacos *en acción* at El Primo trailer. *Photo by Dennis Burnett.*

Page 109. Nilda de la Llata, self-made restaurateur and owner of El Sol y la Luna. *Photo by Dennis Burnett.*

Page 111. Nilda's Veggie Chorizo Migas Taco. *Photo by Dennis Burnett.*

Page 113. Cathy Lippincott *y la familia de* Guero's Taco Bar on South Congress. *Photo by Dennis Burnett.*

Page 114. Guero's Taco Ricardo, a fried egg over pork butt. *Photo by Dennis Burnett.*

Page 115. Nikki Ibarra, Habanero Mexican Café. *Photo by Dennis Burnett.*

Page 116. A plethora of Habanero breakfast tacos. *Photo by Dennis Burnett.*

Page 117. Three generations of breakfast taco making: Pauline Avila, Rose Ann Maciel and Regina Estrada. *Photo by Dennis Burnett.*

Page 120. Joe's Bakery, where every Mexican knows your name—Battered Bacon & Egg and Migas Tacos. *Photo by Dennis Burnett.*

Page 122. Best handshake in town: Juan Meza of Juan in a Million. *Photo by Dennis Burnett.*

Page 125. Don Juan Taco, "El Taco Grande." *Photo by Dennis Burnett.*

Page 126, left. Serving up breakfast tacos twenty-four/seven: Jesus Becerra and his daughter Bianka of La Mexicana Bakery. *Photo by Dennis Burnett.*

Page 126, right. Good way to start the morning: *barbacoa con cilantro y cebollitas* taco at La Mexicana Bakery. *Photo by Dennis Burnett.*

Page 127. Boggy Creek Neighborhood's best-kept secret, *las cocineras de* Marcelino Pan y Vino: Lorena, Maria and Raquel Vargas. *Photo by Dennis Burnett.*

Page 129. Take your pick: *carne guisada, puerco en chile verde* or bacon and egg at Marcelino Pan y Vino. *Photo by Dennis Burnett.*

Page 130. Maria Corbalan, South Austin's Taco Queen and proud owner/founder of Maria's Taco Xpress. *Photo by Dennis Burnett.*

Page 131. Taco Xpress—Your Cantina for Tacos: bacon, egg, potato and cheese and migas tacos. *Photo by Dennis Burnett.*

Page 132. Keeping it Mexican on Manor Road: Aurelio Torres, owner of Mi Madre's Restaurant. *Photo by Dennis Burnett.*

Page 135. Aurelio's house-made Machacado, Egg and Pico de Gallo Taco #9. *Photo by Dennis Burnett.*

Page 137. Sergio Varela, owner of Papalote Taco House. *Photo by Dennis Burnett.*

Page 140. *Para los* veggies: eggs, nopales, mushroom *con tomates. Photo by Dennis Burnett.*

Page 142. Daniel Macias and Virgina Juarez at Porfirio's Tacos. *Photo by Dennis Burnett.*

Page 144. Carne guisada tacos: bestseller at Porfirio's any time of the day. *Photo by Dennis Burnett.*

Page 145. Keeping East Sixth Street bellies full: sister-and-brother team Margarita and Nestor Mendez. *Photo by Dennis Burnett.*

Page 147. Breakfast tacos, served all day at the Pueblo Viejo trailer. *Photo by Dennis Burnett.*

Page 149. Taco Bueno y El Don Chago at Pueblo Viejo. *Photo by Dennis Burnett.*

Page 150. The breakfast taco evolves with Roberto Espinosa, co-owner of Tacodeli. *Photo by Dennis Burnett.*

Page 152. The Jess Special and the Vaquero at Tacodeli. *Photo by Dennis Burnett.*

Page 154, top. José de Loera, owner of Takoba & Tacorrido—*Con un Corazon Mexicano. Photo by Dennis Burnett.*

Page 154, bottom. Behind the scenes in the Takoba kitchen. *Photo by Dennis Burnett.*

Page 155. Takoba tacos: huevos, chorizo, onions, papas y nopales. *Photo by Dennis Burnett.*

Page 156. The next generation of taqueros—Valera family: Carmen, Diane, Juan and Robert Valera, Tamale House East. *Photo by Dennis Burnett.*

Page 160. Tamale House East specialty: bacon, egg, potato and cheese with fresh house-made red salsa. *Photo by Dennis Burnett.*

Page 162. Manuel Lopez Galvan, owner of Taqueria Chapala on East Cesar Chavez. *Photo by Dennis Burnett.*

Page 163. Tacos Tipicos: *nopalitos con huevos, jalapeños y cebollitas asadas.*

Page 164. Founder and executive chef of Austin's own Torchy's Tacos, Mike Rypka. *Photo by Dennis Burnett.*

Page 165. Torchy's Texas-style tacos—the Wrangler: eggs, potatoes, beef brisket and jack cheese. Served with tomatillo sauce. *Photo by Dennis Burnett.*

Page 166. Serving the freshest tacos in East Austin. Reyna Vasquez at Veracruz All Natural. *Photo by Dennis Burnett.*

Page 169. Las migas de Veracruz All Natural trailer. *Photo by Dennis Burnett.*

Page 170. Best breakfast tacos in West Austin: Ray Gonzalez and WhataTaco. *Photo by Dennis Burnett.*

Page 171. Ray's barbacoa and egg tacos. *Photo by Dennis Burnett.*

Page 183. The authors, Mando Rayo and Jarod Neece. *Photo by Dennis Burnett.*

ABOUT THE AUTHORS

MANDO RAYO, EL MUNDO DE MANDO

By day, Mando Rayo is a Latino engagement strategist, and by night he's a self-appointed taco journalist.

As a grassroots *cocinero* and taco aficionado, Mando shares his Latino perspectives and canvasses Austin and beyond to explore all things tacos. While most food bloggers focus on trendy foods and fancy trailers, Mando focuses on the richness of the taco culture. From al pastor to puffy, breakfast to *al disqueada*, Mando chows down on the tastiest tacos Austin has to offer. Through the Taco Journalism blog, fans go behind the scenes with the trailers, trucks and taqueros that make it all possible; witness the stories, traditions and cultures behind the tacos; and see why Austinites are proud taco eaters.

Mando's work is deep rooted in multicultural experiences. Mando offers strategies, content development and trainings that focus on building brands and creating and engaging online communities. Mando was part of the team that developed the Social Revolución, the official Latino event at SXSW Interactive Festival, and has worked for clients including LIVESTRONG, Hispanic Foundation of Silicon Valley, Goodwill

Industries, KLRU-TV, PBS Austin, Blanton Museum of Art and more. Recently, Mando organized the Hispanic Marketing Symposium: State of Mind digital conference based in Austin, Texas. #HMSATX brought together industry leaders and influencers to deepen the understanding of the Latino experience, including LatinWorks, Dieste, ¡NSPIRE!, Batanga Media, Mercury Mambo, Indio and Tecate Beer, Nielson Group and Don Julio Tequila, among others. Mando is a frequent presenter at national conferences, including South by Southwest Interactive Festival and Hispanicize, and has been featured in the *New York Times* and on NPR's *All Things Considered.*

Mando hails from the West Texas town of El Paso, aka El Chuco. Mando lives in East Austin with his familia; he's married to Ixchel Granada de Rayo and has two lovely kiddos, Quetzal Trinidad Rayo and Diego Armando Tenoch Rayo, and a chicken named Elmo.

JAROD NEECE, EL JAROD

I came to love the taco relatively late in life. Growing up in Louisiana, the taco options were—how do you say?—not great. Cajun food is a miraculous and delicious cuisine that I am lucky to have spent so much of my life eating, but there aren't many tacos in this land of crawfish and étouffée. As I got older and started working in restaurants, I ended up at Tampicos Lafayette, Louisiana's premier Tex-Mex, margarita and karaoke destination. This is where I heated up my first tortilla on a grill, ate too many chimichangas to mention and learned how you can turn a $50 bag of raw pinto beans into $5,000.

Then I moved to Austin, Texas, to go to the University of Texas, and my world changed. The tacos were amazing, and they were literally everywhere. As most Austinites, my taco palate evolved over the years—from the late morning stumbling down to Taco Shack to the early morning Tacodeli runs on the way to the green belt to the eventual East Austin taqueria discoveries where the true tacos lie.

Working in restaurants after college provided me a glimpse into the late-night breakfast tacos at La Mexicana and the "Best Reason to wake up before 3:00 p.m.," the Original Tamale House on Airport Boulevard.

As soon as I started working at South by Southwest (SXSW) and met Justin Bankston, our mutual love for tacos and writing about tacos created TacoJournalism. com. The rest, as they say, is taco history, and the love for the tacos has never died. Every day I drive past a new taco truck or restaurant, I wonder if that taco is my new favorite.

TACO JOURNALISM

BY JAROD NEECE

T aco Journalism was started in 2006 when my co-worker Justin Bankston (aka Cornbiter Deluxe) and I wanted to share our love of tacos with the world...or at least with our Austin friends. We were inspired by The Great Taco Hunt blog in Los Angeles and its amazing write-ups of LA's taco trucks and trailers. The blogger was exploring his city and going to places some people might have never tried. We really wanted to do the same thing here in Austin—to let people know where to find the best tacos in town. So we started eating and writing about tacos. It's that simple.

After a few months of writing about our favorite tacos and exploring new taco joints in Austin, we brought on longtime friend and fellow taco lover Mando Rayo. Mando's love for the tacos was strong, and his writing was hilarious. A few more months, and many more tacos later, we decided to bring on another friend and taco aficionado, Gordon Murphy (aka The Commish). With our taco powers combined, we devoured all the tacos in our path. We wrote about the good tacos, the bad tacos, the aggressively mediocre tacos and the tacos that shall never be mentioned here.

Since then, we have been spreading the taco love. In 2007, the *Austin Chronicle* named us "Best Way to Find a Decent Breakfast Taco." We have been interviewed in newspapers and magazines and have led taco tours on buses and bikes and by foot, with the sole purpose of bringing the taco love

to the people. This book is the ultimate expression of our love for the city of Austin, Texas, and the taco, particularly the breakfast taco.

Breakfast tacos have gotten us through hard times (hangovers, lean budgets, late nights and early mornings) and satisfied our cravings on too many occasions to mention. They bring us together with friends and family and are the perfect way to start the day. Allow us to introduce ourselves and tell you a little bit about our taco backgrounds.

GORDON MURPHY, THE COMMISH

Growing up in Indiana, I knew only of The One True Taco, and his name was Crispy Beef. I worshipped him, and he was Good. As the years passed, I became complacent in my faith. I ate of him less often, usually at Orthodox houses of worship, like Taco Bell.

That all changed when I moved to Texas. In Austin, I met a preacher named Justin Bankston, who introduced me to the delightful mysteries of Al Pastor on a homemade tortilla. I saw the Light! A few years and many tacos later, Justin asked me to join Taco Journalism and help spread the Good Word.

From time to time, I still enjoy a guilty crispy taco, but now I worship many Taco Gods: Al Pastor, Barbacoa and the mighty Breakfast Taco.

JUSTIN BANKSTON, CORNBITER DELUXE

I was born and spent my first eighteen years in the Rio Grande Valley in deepest South Texas. We had both kinds of food: Tex and Mex. I learned to use a tortilla as a utensil before I learned to walk.

When I moved to Austin in 1991, I immediately began enjoying the wider variety of foodstuffs available, but my first love has always remained the strongest. I've been exploring the Mexican food in Austin ever since and have enjoyed every minute of it.

Once I started working at SXSW in 2004, I made fast friends with Jarod Neece, and our mutual adoration of tacos led to many delicious lunches and intense discussions. We felt like we had more passion for tacos than just two people needed, so we launched tacojournalism.com to share the love. My alter ego, food writer and raconteur Cornbiter Deluxe, was born.

Mando and Gordon joined up soon after, and together we continue building the community resource that is tacojournalism.com. Mando's incredible passion and vision have led to this book, and I'm very proud of him and it.

JAKE AGGER, EL TACO INTERN

My graduation from high school in Washington, D.C., my birthplace, marked not only an imminent relocation to Texas to attend the University of Texas at Austin but also a shift in what I so regularly considered the taco. Growing up in Silver Spring, Maryland, a staple of family dinner was seasoned ground beef inside hard taco shells with a variety of condiments. We loved it. I still love it. But since moving to Austin, I've slightly moved on.

My arrival in Austin and matriculation at UT was met with a simultaneous graduation from store-bought, hardened taco shells to fresh, daily-made, pillowy tortillas. Between the two, the contrast was vast. I would never be the same. A year following the beginning of my collegiate life, I began to read Taco Journalism religiously. The mission was to find the best tacos, and I was sure this blog would prove a valuable resource. Nobody could hold me back.

In the midst of my final year at UT, the Taco Journalism team announced the news that a breakfast taco book was forthcoming, and they would need some help with it. I happily took on the challenge and became El Taco Intern, conducting research, scheduling, taking notes, eating tacos, drinking cervezas and writing—all in support of this gold mine of a book.

ABOUT THE PHOTOGRAPHERS

DENNIS BURNETT

Dennis is a freelance photographer based in Austin, Texas. He has recently relocated to Austin after spending the last decade in the beautiful, historic city of Savannah, Georgia. He graduated with honors from the Savannah College of Art and Design, where he earned his BFA in photography.

Upon graduation, Dennis was offered a full-time position with SCAD as one of its premier photographers. It was through this exclusive opportunity that he honed many of his innate skills with still photography and creative art direction but also found a new skill set that he was just as passionate about: filmmaking and cinematography.

With his trained eye for detail, a sense of humor and a style rooted in documentary photography, Dennis is able to fulfill the needs of editorial, commercial and corporate clients. Much of his personal work focuses on the stories of observation, raw emotion and authentic moments, all of which focus on showcasing the genuine story of the human soul and how we interact with one another. Visit his website at www.DennisBurnettPhotography.com.

Joel Salcido

Joel Salcido grew up with one foot in Mexico and the other in the United States. That's why he juggles two languages, two cultures and two visions of the world.

He became a bit more worldly after working ten years as a photo journalist, winning awards along the way as he traveled to mostly Latin American and European countries. After several trips to Spain, he decided to move there in 1999 and launch his commitment to fine art photography. His images now reside in the vaults of the Witliff Collections at Texas State University–San Marcos, the El Paso Museum of Art, the Harry Ransom Humanities Center at UT-Austin and the Museum of Fine Arts, Houston. His latest acquisitions have been made by the Federal Reserve Bank, the University of San Antonio and the University of International Business and Economics in Beijing, China. He is on the verge of unveiling his new series on tequila. *Salud!* Visit his website at www.JoelSalcido.com.